CLUCK

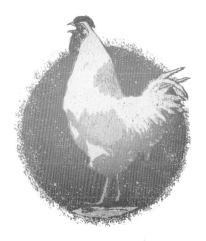

CLUCK

From Jungle Fowl to City Chicks

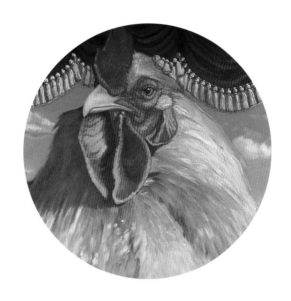

Art by **S.V. Medaris**
Stories by **Susan Troller**

Additional stories by
Jane Hamilton, Ben Logan, and Michael Perry

ITCHY CAT PRESS
Blue Mounds, Wisconsin

Library of Congress Cataloging-in-Publication Data

Cluck : from jungle fowl to city chicks / art by S.V. Medaris ; stories by Susan Troller ; additional stories by Jane Hamilton, Ben Logan, and Michael Perry.

p. cm.

ISBN 978-0-9815161-3-4 (soft cover : alk. paper)

ISBN 978-0-9815161-4-1 (hard cover : alk. paper)

1. Chickens—Anecdotes. 2. Chickens—Pictorial works. 3. Chickens—Humor.

I. Troller, Susan, 1952- II. Medaris, S. V.

SF487.3.C83 2011

636.5—dc22

2011004509

Designed by Flying Fish Graphics

First edition, first printing

Printed in Korea

Itchy Cat Press

Blue Mounds, Wisconsin USA

ffg@mhtc.net

www.itchycatpress.com

10 9 8 7 6 5 4 3 2 1 buk, buk, book

For Howard, always game.

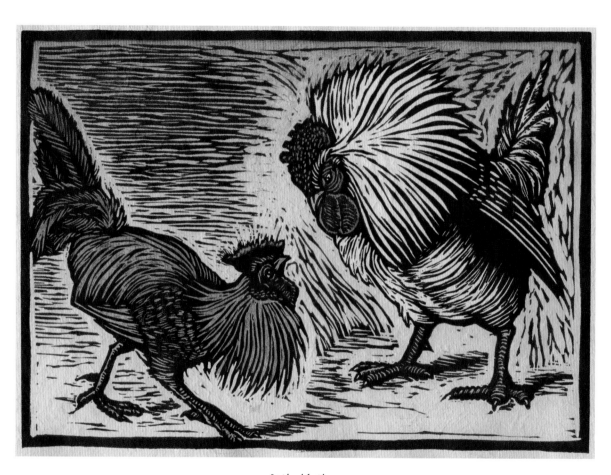

Intimidation

CONTENTS

ACKNOWLEDGMENTS

My biggest surprise in writing about chickens was the discovery that nearly everyone has a chicken story. Thanks to all who gave me advice about raising my own birds or contributed their poultry tales, including many members of the Hundt-Bergan clan, Ron Kean, Al Hefty, S.V. Medaris, Virginia Sanborn, Anna Landmark, Bonita Sitter and Fredericka Schilling, Gil Williams and Judy Ettenhofer, Bob Holmes, Martha Pings and Liz Perry.

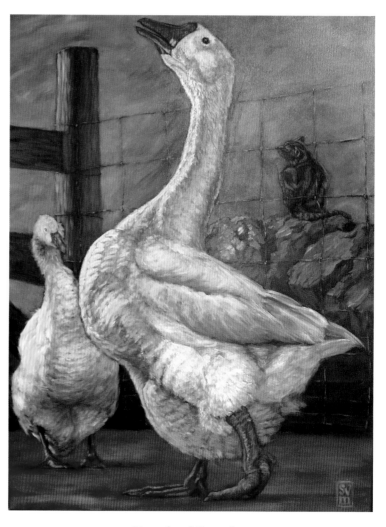

Farmland Security

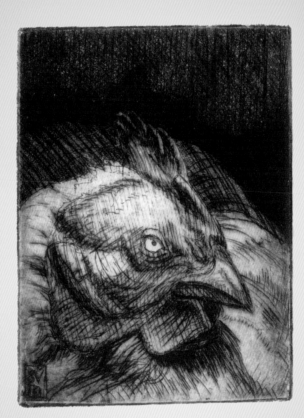

Betty

WHY . . . CHICKENS?

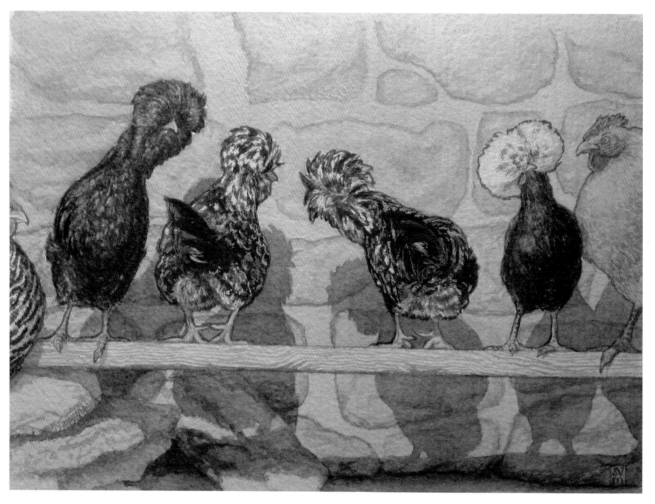

A Hen Party for Alicia

From barnyard to backyard, lowly hens have fluffed up their feathers and flown the country coop.

Newly welcome in cities from Portland, Maine, to Portland, Oregon, they've become pets with a purpose, supplying eggs for the table, fertilizer for the garden, and laughs—lots of laughs—for their city slicker friends.

In recent years, chicken fans have successfully sought zoning changes to allow hen housekeeping in many urban and suburban areas. The result is a boom in backyard poultry, quite a journey from jungle fowl to city chicks.

Although roosters remain unwelcome in most urban or semiurban settings—probably a good thing—the newly chic hen is definitely something to crow about if you've caught chicken fever.

The chicken's current role as a quirky urban status symbol is apparent in a variety of ways.

There are innumerable chicken Web sites and chat rooms, full of newbie fowl aficionados learning how to set up brooder lights for baby chicks or asking questions about acceptable rooster behavior and egg-laying etiquette. You can go into many chichi urban pet stores and find chicken supplies, including pricey organic food, right next to the designer dog leashes and handcrafted cat climbing trees.

In neighborhoods that have really gone crazy for chickens, regularly scheduled henhouse tours are popular, and allow fowl fanciers an opportunity to take a peek at other people's poultry palaces and cleverly painted coops. It's kind of like a parade of homes for hens and their friends.

There's also been a surge of city kids showing their chickens in 4-H classes, and growing interest in ornamental chicken breeds with spectacular feathers, colors, or unusual characteristics, from Jersey Giants to the tiniest of bantams, from Frizzles to Silkies.

In addition, a new generation of small acreage, back-to-the-land young farmers has stirred growing interest in sturdy, practical heritage chicken breeds our great-grandparents might have known and loved. While industrial-scale chicken farms utilize birds that have been very specifically adapted for fast growth or phenomenal egg production, those who keep a small flock of chickens at home often favor old-fashioned, dual-purpose chicken breeds good at supplying both eggs and meat.

For keepers of small backyard flocks, disposition matters, too. Anyone keeping chickens primarily as egg-laying pets will tend to choose a winning personality over a speedy

conversion from chick to fried chicken.

Few would argue that keeping a tiny flock of chickens for home-raised eggs is a moneymaking proposition for urban or suburban dwellers. Instead, keeping chickens is primarily a labor of love as well as a very direct way to connect with the food we eat.

The current craze for chickens at home coincides with the trend toward wanting to know more about the sources of our food. Recent scares associated with factory-scale farming of eggs, meat, and produce have created a greater appreciation for the virtues (and good taste) of providing them locally. Like planting and harvesting a garden, or buying from a farmers' market, keeping chickens gives us a sense that we have some control over that most basic of needs: providing nourishing food for the table.

But keeping chickens isn't just about being virtuous or nostalgic; it's also surprisingly fun. With their variety of vocalizations, their fundamentally whimsical behavior, and their interesting interactions with each other and the natural world—bugs, breezes, anything that looks like food, or a real or imagined enemy—chickens are undeniably entertaining.

And although they've been part of human life and civilization for almost ten thousand years, part of the charm of chickens is that they remain essentially and relentlessly themselves, little affected by human rules of fair play, morality, or etiquette. As we raise fragile little chicks, gather eggs, clean the coop, feed and water our flock, protect our birds from predators, and even butcher our chickens, we become both actors and observers in their chicken-ish lives.

When we keep chickens in any setting, rural or urban, we, too, become part of the cycles of life, death, and everything in between that's always helped dignify the dirt and work, hardship and uncertainty, of farm life. Plus there's that other side of the coin of living with animals . . . the funny and the ribald, the brave, the bizarre, the tender, and the beautiful.

In a world where much seems plastic, fantastic, and phony, chicken keeping is the very definition of down-to-earth. There's a surprising amount going on, and it's a reminder that we, too, are part of the big wheel of life. That's what this book of art and essays is about.

26 Billion Chickens Can't Be Wrong

It is estimated that there are about four chickens for every human on Planet Earth.

Of course, the vast majority of humans today have no direct contact with chickens or much of the rest of the natural world because so many of us live in large, centrally located confinement facilities we call cities. Meanwhile, birds raised in industrial conditions have impoverished lives, too, providing them with no experience of sunshine, dirt, bugs, grass, or meaningful contact with their own kind. Or with humans, for that matter.

This modern estrangement of our two species is unfortunate, and we are both poorer for it because chickens have been such a central part of human culture and language for thousands of years.

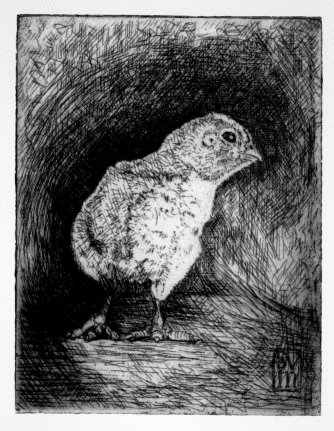

Broiler Chick

THE JOY OF CHIX

Chicken Littles

I've spent a lifetime loving animals. Over more decades than I want to tell, I've raised and rescued countless critters, from rabbits to raccoons, heifers to horses, angora goats to zebra finches. I now live on a small hobby farm for the express purpose of having as many animals as I can stand.

But, sadly, no chickens.

In fact, my only experience with farm fowl, other than transporting some young ducks cross-country in a horse trailer, involved keeping a couple of sad little Easter chicks in a city apartment when my brothers and I were small children.

All that changed when I agreed to write some stories about chickens to go with artist Sue Medaris's remarkable chicken art. Finally, I could give my husband, who had a strong bias against feathered farm critters, a practical reason to get some chickens.

"I'll need to do some research, and, ah, it would be more authentic, and, ah, easier . . . really, a lot easier . . . if I just had to check out some chicks and chickens in the backyard. And, of course, I'll do interviews, lots of interviews, with other people, too," I explained to the long-suffering Howard. He may have been skeptical but he agreed it was time to end the chicken drought.

Like almost anyone with a fresh case of chicken fever, I was dazzled by the variety to choose from: the colors, the sizes, the characteristics, the purposes, and the hundreds, literally, of breeds and variations.

Where does one even begin to begin? I started by asking myself some basic questions.

Did we intend to eat these birds and fill our freezer with home-raised fowl? Or were these chickens destined to be pets? Although we're not vegetarians, we're mindful of where our meat comes from, and we buy beef and pork only from farmers we know. But could we take that next step and raise chickens for our own table? I figured we'd have to get to know them first. By then it would probably be too late and instead of their providing nourishment for us, we'd be providing it for them, until they dropped dead of old age sometime in the far distant future.

Next I contemplated whether we wanted these birds as laying hens. Yes, definitely. Next we had the choice of white, brown,

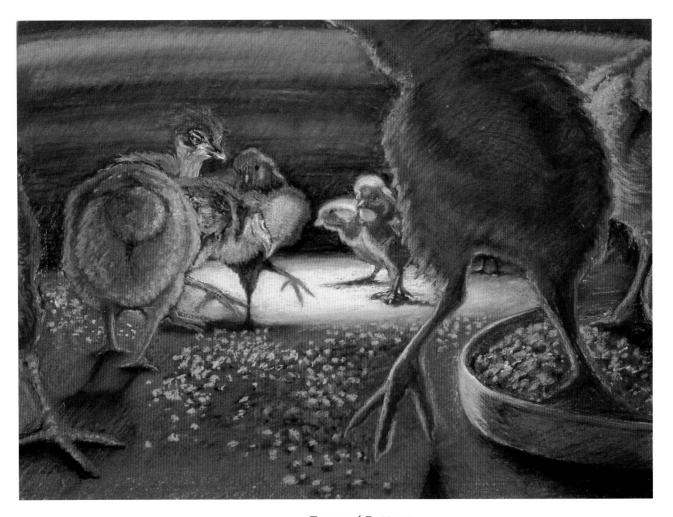

Tops and Bottoms

blue, or green eggs. What kind of quantity? Yikes. Who could say? We like eggs, but how many do we need? Would anyone buy them from us?

Then there was the issue of whether we'd want to raise any more chickens, and, if so, did we want hens known as good mothers or would we consider hatching chicks in an incubator?

Did we want birds that were tame and friendly, or tough and resourceful? What about aesthetics like feathered legs, rosecombs or pea combs, beards and ear tufts, frizzled feathers?

What kind of housing would we be able to provide, and how would we keep a small flock of hens safe and sheltered from sweltering Wisconsin summers and brutally cold winters? The list of considerations, of possibilities and permutations, seemed almost endless.

In the end, I figured we needed a fundamentally hardy breed so we weren't subjecting delicate chickens to the inevitable steep learning curve of beginners.

Fortunately, our friends Lars and Corina, successful organic farmers in the beautiful coulee country 100 miles north of us, are big fans of Buff Orpingtons and suggested they'd be a good choice for us. "Good layers, even during the winter, cold tolerant, good mothers, nice to be around, and they're pretty as can be. Friendly, too," Lars told me.

It didn't take much convincing, especially when I learned Lars was sending a clutch of eggs to a young friend who wanted to hatch chicks in an incubator. Lars said he'd be happy to sell some chickens when the babies were about a week old.

When the call came that the chicks were ready to go, we were, too.

We had prepared a safe, warm spot in our secure garage. There was a brooder box and warming light to welcome the little peepers home. We had chick starter food and a one-pint Mason jar to attach to a small waterer.

Besides the accommodations, we were prepared in other ways, as well. I'd become a book expert on common chick ailments; I was even prepared to deal with problems like pasting up, or, as our friends Gil and Judy call it, "pasty butt." Not a pretty description, but apparently accurate.

Best of all, my formerly reluctant husband had become a willing partner on the chicken project, researching henhouse designs and scouting building sites not too far from the house, and not too far from the horse barn. Good thing, too, seeing as I saw myself as chief chicken wrangler, not coop carpenter. If the chickens had to depend on me for shelter, they would likely have to live in pallets wrapped in plastic, secured with bungee cords and duct tape.

So as we set off to get our chicklets, we weren't worrying about when we'd get our coop complete. After all, we knew our small charges were still of a size where they could comfortably travel in a shoebox with a hand towel for a bed. And really, they were just a few chickens—five dollars each. How much trouble could they bring? For less than the price of a tank of gas, it was the beginning of a chicken adventure.

Sexing Chicks

Those two words, "sexing chicks," conjure notions of a sleazy Internet site or some kind of boorish fraternity row behavior.

But among chicken folks, "sexing chicks" is a descriptive, respectable phrase that refers to the art, science, and actual act of figuring out the gender of your baby chicks. Guess what? It's not easy. Even among expert chicken-sexing practitioners—and the numbers of these useful folks are diminishing—the accuracy rate is only about 90 to 95 percent.

Given this reality, it's obvious that among chicken neophytes it's a common occurrence to discover that cute little Henrietta is actually the noisy and rambunctious Henri. Even when purchasing baby birds from a hatchery or breeder, there are a certain number of oops incidents when it comes to sexing chicks. Anyone having a pet city chicken or intending to ultimately get some eggs, or both, will definitely be looking for girls who will grow first into pullets (juvenile female chickens under a year old) and then into hens. Roosters, for many reasons, are mostly unwelcome within city limits. And it's not necessary to have a rooster around for hens to lay eggs.

So how were we going to make sure we had a small flock, say, three to four hens, of Buff Orpingtons?

We figured we'd take a hopeful chance with the law of averages with about six chicks. And we'd keep our fingers crossed that half, or a little more, would be girl birds. We especially wanted to start with chicks because we wanted our chickens to be tame and responsive and the best way to ensure nice behavior, we'd heard, was to begin with very young birds.

But I was worried that the rather identical-looking little Orps might turn out to be a passel of brash boys, not docile little hens. Plan B, somewhat hazy in terms of details, was that, if necessary, we'd provide a short-term but exemplary home with plenty of food and recreation for any or all cockerels—young roosters—for several months. In exchange, they'd contribute to our freezer stockpile of winter meals.

Lars had suggested we might ultimately want to consider keeping a rooster with our group of hens because it creates a more natural chicken tribe. I had my doubts. I'd heard plenty of horror stories about roosters and their bad behavior. It seemed as if every time I told someone I was getting some chickens, or writing some stories about

chickens, I'd get an earful about the rooster that attacked Aunt Maude or made little Sally cry or bullied the hens 'til they were bloody. I figured I'd save the girls and myself some trouble by operating a nice little chicken convent with chaste, unchased hens and no marauding roosters to ruffle any of our feathers.

And that was the theory, until I met my chicks.

Meet the Orpingtons

I'm sure no one chooses Buff Orpington chickens simply because they sound so posh, but it probably can't help but polish their reputation among would-be chicken fanciers, at least a little.

When I read through the venerable, lavishly illustrated catalog of the Murray McMurray Hatchery, I was impressed with the charming, old-fashioned description of this pretty, cold-hardy breed: "One time, years ago, at our Hamilton County Fair the poultry judge was asked to describe the correct plumage color for this variety. Taking out his gold watch he said, 'That's the color for Buff Orpingtons.'" The catalog copy continues, "And pure gold they are, symbolic of great value and high quality. Introduced from England in the late 1800s, they became one of the most popular farm fowl in this country. These are large, stately birds of quiet disposition."

Wow. "Stately birds of quiet disposition" sounded unlike anything else we had ever raised on our farm. Our dogs can accurately be described as energetic, our cats as rambunctious, and our wily horses seem to take pleasure in every sort of mischief. Even our now lovely grown daughters were once small children who never slept and built catapults for their dolls. So we figured it would be quite a pleasant shift on our farm to have chickens whose name and demeanor suggested serene country clubs, or who might show up on the social register among Who's Who of American barnyard stock.

With Buff Orpingtons on our farm, I could imagine we might have a chicken wedding, with the invitations from our little flock reading something like this: "The Buff Orpingtons request the honour of your presence at the marriage of their daughter, Miss Muffy Buff Orpington, to Mr. Wilfred Welsummer."

As we drove to the farm where our chicks had been incubated and hatched, I imagined that the little critters—these young Orpingtons we had never met—might look the part of upscale, old money chickens, even as babies. For all I knew, they could be wearing argyle socks and tennis sweaters. I mused to Howard that these little birds might know how to play golf, or would expect to and we wouldn't be much help, considering it's a sport neither of us has ever even tried, unless you count miniature golf. He just shook his head and kept driving.

In reality, the little birds were in a wire pen, with nary a golf club or tennis sweater in

sight. Even so, they were undeniably adorable. Set up in warm sunshine next to a wall where they were well protected from the soft spring breeze, the pen held the six richly glowing golden chicks. They were active and big-eyed, plucking at bits of grass as they explored a bright new world. And with them were two much tinier chicks, one striped and one black, both sporting tiny little crests.

Young Noah, the ten-year-old boy responsible for successfully hatching the eggs from Lars and Corina's Buff Orpington flock, shyly explained that he'd also had a couple of bantam eggs. So he added them to the clutch of Buff Orpington eggs in the incubator. Voilà, here were two extra chicks among the group, hatched at the same time. Although much smaller, the banties had no trouble keeping up with their larger surrogate siblings; even better, there appeared to be no squabbling or pecking among the youngsters. Noah told us he wanted to keep the bantams, because he expected they would have some interesting characteristics, like feathered legs, wild colors, and perhaps tufted beards and muff, plus that funny little crest of feathers on their heads.

They were, without question, the cutest things I had ever seen.

All of the chicks, large and small, were tame and friendly, clearly accustomed to being gently handled; Noah had done his chick-rais-ing chores admirably well. And seeing as he was in the chicken business, the professional, actually, with plenty of other farmyard fowl dashing about the property, I only felt a little guilty as I tried to wheedle him out of his dar-ling little bantam chicks.

"You want them all? You want to buy all eight of them? Not six?" Noah asked, a little doubtfully.

"Yup. And I'll pay you extra because they're all so well trained," I said briskly. He seemed to brighten up. I confess, I was won-dering what kind of adult would try to talk a boy out of his cute little chickens, using bribery as well as flattery. But it didn't stop me from getting out my checkbook, hoping Howard would remain near the truck, chatting with Noah's father about the trout stream run-ning through their property.

"Well, I wasn't sure what I was going to do with them . . . I don't know if they're girls or boys . . . We've got quite a few chickens," Noah mused, scratching his head. If it was a clever sales act, the boy has a great future on the stage.

"Doesn't matter. I'll take the whole bunch," I said firmly. "Why, you did such a great job with this batch you can probably raise some more, just like these. Plus, it might be kind of sad to separate them," I said. Then, shamelessly, I handed over the check.

Noah seemed pretty happy as he helped me catch each chick and place it, carefully, in the travel box. If he was having misgivings, or second thoughts, he graciously kept them to himself. I, of course, was thrilled. There's nothing like new pets to turn a good day into a glorious one.

It wasn't until we were pulling out of the driveway, waving goodbye, that Howard looked closely in the box.

"Hmmmm. Are you sure there are just six? Looks like more. I thought they were supposed to be gold. How did that black one get in there? Was there a mix-up? Do we need to go back?" he asked. He sounded confused, or concerned.

"No mix-up. We just got a couple extra little ones. They won't grow very big. I think they'll help with the research. In fact," I said, "I'm sure they will."

Big Hands, Little Hands

Chickens have a reputation for stupidity. Consider the terms: birdbrain, dumb cluck, feather brained. Even the term "flighty" is no compliment.

But on some subjects, chickens can be quick, or at least instinctive, learners. For example, when it comes to important lessons about who's a friend and who's a foe, chicks can be surprisingly quick and discerning.

My first experience with this variety of chicken smarts came when I visited some friends before I got my own birds. Waiting for my chicks to hatch, I jumped at the chance when Anna and Steve invited me to take a look at the two dozen Delaware chicks they had purchased from a hatchery and intended to raise both as laying hens and for meat.

"You'll love them," Anna had told me as soon as her chicks arrived. "Come and see for yourself."

She suggested a chick tour, beginning in her garage, where she had been keeping the birds since they'd arrived in late March. She knew I was eager to learn about things like brooder lights, bedding, and the length of time chicks could go between feedings. In addition, I was interested in seeing what kind of setup she and Steve had figured out for the chicks' permanent coop near their sheep barn. And, as a chicken newbie, I was also curious about what their chicks, the old-fashioned, dual-purpose Delawares, looked like.

At about a month old, the Delaware chicks were big, strong, and healthy, beginning to get feathers, and no longer the balls of downy feathers I had expected. In fact, they actually looked rather gawky. They were cute in that middle school kid way, a little awkward, looking like their body parts didn't exactly match.

These birds obviously were enthusiastic eaters, and when they heard Anna's voice, they made lots of noise. When she opened up their cage area to add some bedding, give them a little extra food, and check their water, I was surprised at how they raced toward her hands and crowded forward, each cheeping in a slightly different way, as if trying to get her attention. As she leaned down into their pen, one even jumped up on her shoulder, and we both laughed.

"They like you!" I said. I didn't know chickens were demonstrative.

"Well, yes, they like being fed, and they know who takes care of them. And they're really pretty funny," she said, stroking one of

the little birds as he, or she, pecked at her fingernail. Then Anna's two-year-old, Alice, appeared, wanting a peek at the chicks.

When Alice leaned forward to get a closer look, reaching toward the chicks, they scattered. She laughed, lightly pounding on the side of the cage with her tiny hands. Most of the birds raced toward the back of the enclosure, as far from the marauding fingers as they could get. But one particularly tall chick drew himself up and hopped forward, looking threatening.

In a moment, what had been a love fest turned into something else. And, clearly, the chicks saw a difference between the small, slightly scary hands, and Anna's hands, which they knew were comforting and trustworthy.

Anna deftly scooped the baby up, who was still laughing, and soothed the chicks. As she spoke, the birds cocked their heads to listen. Seeing no more alien little hands, they settled down immediately, peeping and pecking at their food.

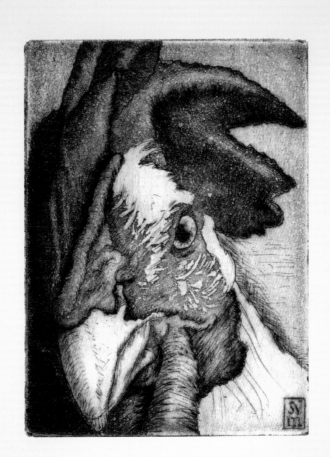

Fat Bastard #37

WICKED ROOSTERS . . .

...This Way Come

Talk to people with any experience with chickens and they are likely to tell you a bad rooster story. These stories run the gamut, from the tough old bird who seemed to lie in wait for the school bus each day so he could chase shrieking children down the driveway to the aggressive young rooster who was so rough with his hens that several couldn't be saved from the wounds he inflicted during mating.

Fierce, unrelenting, and equipped with a surprisingly effective arsenal of stabbing beak, sharp spurs, and battering wings, a mean rooster is, quite literally, a pain. He can be sneaky, and he may appear to plan his mode of attack. Bad-apple roosters seem to have far too much fun ruffling feathers, drawing blood, and creating a commotion. They pick fights and strut away afterward, happy for the adrenaline rush. Even many otherwise devoted animal defenders are adamant about bad roosters: If they can't be trusted, and if they can't be nice, get rid of them.

Some of these ferocious fellows may be aggressive with just about anyone—people and other roosters; cats, dogs and other domestic critters; various wild predators; and even members of their own flock. In fact, anything that comes near, by land or air, is fair game.

Other roosters are quite specific and selective. They can't stand white chickens, or spotted kittens. They detest the mail carrier, or at least the mail carrier's shorts in summer. They hate women. They'll go after anyone in a hat. They are pushed into a rage by anyone carrying grocery bags, or pulling a wagon, or wearing a floppy coat.

Suffice it to say that there are legions of former farm children who recall chicken duties as fraught with peril, not just from the occasional cranky or broody hen but from roosters who seemed to take particular joy in terrorizing small humans.

There's Mary, who, with her brothers and sisters, walked the mile home from school each day.

Thirsty, and often hungry, the children would sometimes pay a visit to their grandmother, who lived on a small farm between school and their home. Not the generous or gentle sort, the old woman expected a certain amount of work from her young descendants in exchange for a glass of water, a piece of bread, or a slice of apple.

One day six-year-old Mary was asked to pick beans in the garden in exchange for her small snack. Picking as quickly as she could, and minding the basket carefully so she

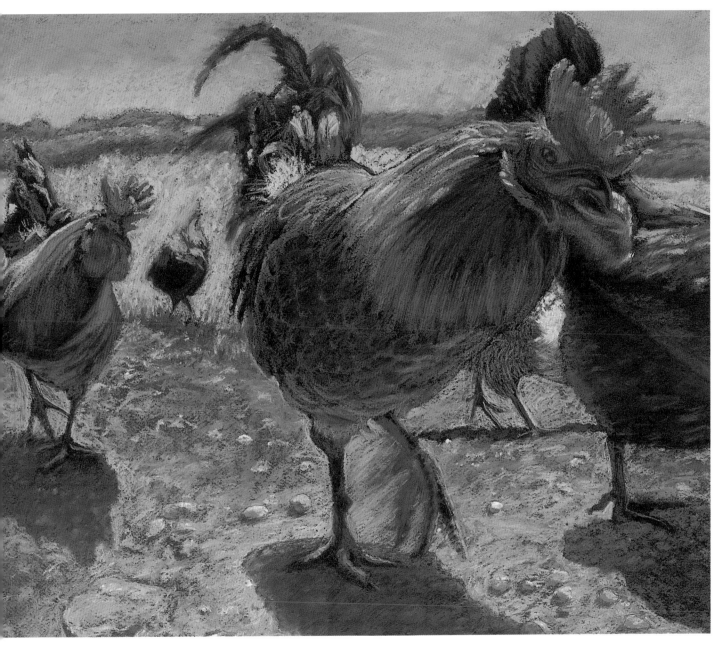

On the Run

wouldn't waste any beans, Mary never saw her grandmother's most vile-tempered rooster approaching. He gave no warning as he pounced from behind, pecking her head, spurring, and scratching her neck and shoulders. Even when she shrieked and flailed, dropping the basket of beans and sprinting across the yard, the rooster hung on, acting like a cocky rodeo cowboy who'd drawn a particularly frisky pony. Disapprovingly, Grandma watched the spectacle from the house.

Hearing the commotion, Mary's uncle raced to her rescue, using his hat to beat the bird and free the howling child. Knocked to the ground, the rooster jumped up, dusted off his wings, and strutted off, showing no signs of remorse. And neither did the fierce old grandmother.

"Why do you keep that damn bird?" Mary's flustered uncle shouted as he put the sobbing child down in the kitchen.

"Well, you have to say, he does keep the kids in line. And, Mary, don't forget, you dropped the beans." When Mary recalls the story, she says she isn't sure who was meaner, the rooster or her ferocious old grandmother.

❖

Then there's Franklin. As a teenager, he had graduated from chicken chores to field chores that involved bigger responsibilities with tractors and other machinery. But he still remembered his own tasks around the chicken coop fondly, and he was sorry his adored little sister was miserable as she went about her egg-collecting duties and her job of providing food and fresh water for the chickens.

She confided that what she objected to had nothing to do with her jobs, or the hens. But she was afraid of the flock's overly conscientious rooster, who threatened the little girl every time she approached the coop to get eggs.

Although he never actually attacked her, he puffed himself up, crowed loudly, and glared at her with that distinctly fearsome thing, a chicken evil eye. His behavior would have scared anyone, but it was particularly intimidating to someone who wasn't all that much bigger than the bird himself.

Franklin was in a quandary. He didn't want to hurt the handsome rooster, who was, after all, only doing his job, using threats and displays. But he knew he couldn't always be around to give his little sister confidence and protection. And he also knew enough about chickens that he figured any training program would have to be quite uniquely designed to be effective.

So he determined to fight fire with fire—in this case, threat display against threat display. When the rooster crowed that lusty universal cock's call, "I'm here, I'm great, I'm the boss, I'm in charge! I'm in charge! I'm in charge!" Franklin decided he would crow back, louder, longer, more aggressively.

The first day, it made his sister laugh, and Franklin thought it did seem to confuse the rooster a little. So he thought he would try it again. The next day, as soon as the rooster started crowing, Franklin responded by crowing even louder. This time, he was

sure the rooster's crow sounded a little less belligerent, a little less confident, a little less, well, cocky. The plan was working.

On the third day, as soon as Franklin let out his dominant crow, even the rooster's ruffled feathers and threat pose disappeared and his sister could collect the eggs without having to fear a sneak attack. But Franklin figured he'd keep up his counter-crowing just to see what would happen.

By the next day, all the rooster could manage was just a defeated little squawk.

Within a week, the once-feared rooster had drooped into a funk, never to crow again, a shadow of his former lusty self. Franklin's sister no longer had anything to fear. For that matter, Franklin reports now, neither did the hens.

❖

Our old friend Dan is in his eighties now, and he said he was ready to confess something about a rooster he had never admitted.

"There was a really mean old son-of-a-gun rooster at my cousin's house. He'd always go after us kids," Dan recalled. "My uncle was kind of a tough guy himself, and he told us if we'd just leave him alone we'd be fine. But it never seemed to work out that way. I'll tell you, we were scared of that thing.

"One day my cousin and I were going fishing, and we were carrying our poles and a bucket of worms, and heading down toward the pond. That mean bugger came after us, and, boy, we were running. Dropped everything and just ran. I was older, and faster, so I

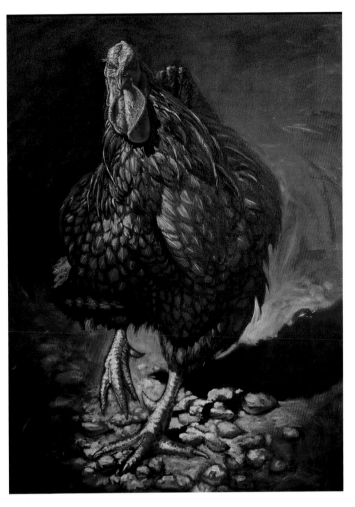

Maximus Advances

got out in front, and then hid behind a tree," Dan said.

As the rooster caught up with his cousin, who was yelling for help, Dan picked up a rock, a nice smooth rock, just a little smaller than a baseball. Using his entire eight-year-old pitching strength, he aimed at the rooster, who was ruffled and ready to pounce, and let fly.

"Darned if the rock didn't hit that bird right in the head, and he fell over. I think us boys

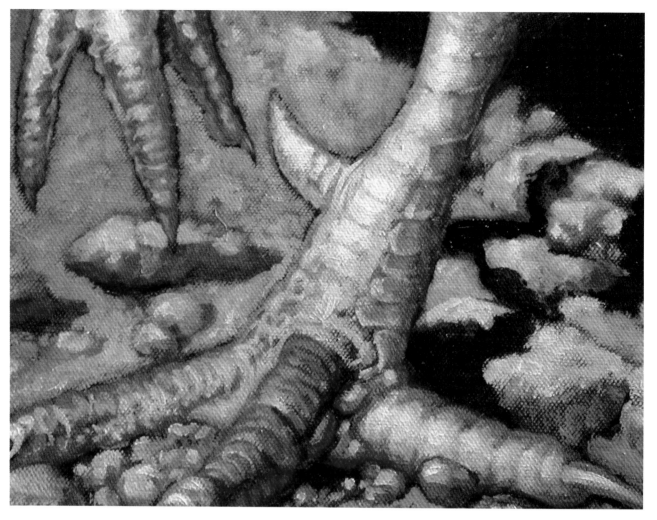

Maximus's Feet

were even more surprised than the rooster," Dan said, grinning at the memory.

"'Dan, I think you killed him,' my cousin said. 'Or at least he's hurt pretty bad.' Then he looked at me and looked even scareder. 'Dad's gonna be awful mad.'"

With the rooster lying in the grass, the boys now had another, bigger problem.

"My cousin said he had heard that chickens can be fixed from all kinds of injuries or ailments if you put their heads in water," Dan reported. "Maybe he just made that up but we didn't know what else to do so we carried the rooster to the pond and put his head in the water."

As a friend to chickens, I hoped the story would have a happy ending, something along the lines of the rooster springing back to full health, but with a miraculously new gentle disposition.

But that's not how this story ends.

"What happened?" I asked.

"I guess he drowned," Dan reported. "Anyway, he was definitely dead when we got him out of the water. So we gave up fishing for the day and took a real long walk in the woods instead.

"My uncle always wondered where that rooster went to and what ever happened to him. Sometimes he'd kinda shake his head and say he never figured a hawk or a dog or some other critter could get him, 'cause he was so damn mean."

❖

There's also our young friend and neighbor Ellen, who was raising chickens for a 4-H project. Besides hoping to show her birds at the county fair, she intended to sell the fresh eggs from her eleven hens. Because she was going to also raise some chicks from her pretty, purebred hens, she kept a rooster in with her flock.

At least that was the plan until our normally gentle, friendly little dog Tikki paid a brief but savage visit to Ellen's coop, killing every single bird.

In the aftermath of the massacre, we sat in the living room, along with the delinquent dog, who could tell she had made her little pal terribly unhappy. So we sat, sharing a box of tissues and crying together, thinking about how scared the poor hens must have been, what a mess it was, what a waste, how hard she had worked to raise the chicks and get the pullets to laying age.

"There were an awful lot of feathers," she sniffed, sadly. I nodded and handed her another tissue, dabbing at my own eyes, too.

Then she brightened up considerably and gave me a shaky little smile.

"Well, there's one really good thing about it," she said. "At least Tikki killed the rooster. And I really, really hated him. So maybe it was worth it."

❖

Before you get the wrong impression, not all roosters are mean, either to people or to their hens. But most are undeniably

colorful characters, in terms of behavior as well as their spectacular plumage. In addition, there's that certain defining attitude that is, quite accurately, known as cocky: the strut in the walk and the insistent crow that's the chicken world's equivalent of Tarzan's jungle shout.

Unfortunately, even some perfectly pleasant roosters are such enthusiastic, ardent suitors, especially toward their favorite hens, that the unlucky objects of their affections wind up with bald spots on their backs and shoulders. It's not just a cosmetic problem. Any chicken with exposed, raw, or bloody-looking flesh is vulnerable to pecking by other chickens. A tendency toward cannibalism among chickens isn't pretty, but it's a real worry when there's a weak or injured bird.

Thus there may be a legitimate need for small chicken jackets (I swear, I am not making this up) to protect defeathered members of the flock. Known as chicken saddles, or sometimes aprons, they attach over the wings and protect the neck and back. The little garments are sometimes decorated, although I think if I were a hen I'd probably never come out of the nest box and into day-

light if I were wearing a chicken saddle emblazoned with a logo of the Green Bay Packers or, even worse, the Miami Dolphins. Honestly, even a tulip or an embroidered chick would be plenty humiliating.

At this point, you might legitimately ask: Does any rooster have sufficient redeeming characteristics to bother having him around? After all, hens are perfectly capable of laying eggs without male companionship. Furthermore, roosters are strictly and specifically forbidden in almost all urban areas that are now enthusiastically welcoming small backyard flocks of hens.

The answer is yes, and not just for professional chicken breeders and poultry fanciers. There are roosters who protect their flocks without harm to anyone except potential predators, and roosters who are not only beautiful but amusing and interactive. And then there's Big Tiny, a great rooster who was both friend and muse to Sue Medaris. He was much more to her flock of hens, and any other chicken he encountered.

Big Tiny

Rest his feathered soul, Big Tiny was a ladies' man.

Big Tiny, or Big Boy, as he may have been known in particularly tender or intimate moments, was an exemplary Buff Orpington. Like most Orpington roosters, he was a large, blond, handsome fellow, imposing and attractive.

Surprisingly, for a rooster, he was neither vain nor arrogant, when he could have been both.

Big Tiny had the confidence of a born leader, and, as a result, he never seemed to be in a hurry. He had a calm, capable demeanor in all kinds of company.

As other, lesser roosters squabbled, fluffed, and fought, Big Tiny strolled on by, magisterial and measured. "Let them sort it out. I have more important things to do, like find some bugs for these fine hens," he seemed to say.

Naturally, as Sue tells it, the girls couldn't get enough of him.

"When Big Tiny came out of the coop, there was always this kind of a thrill, and it just looked like the hens were swooning, you know?" Sue recalled. "It was always like, 'Oooooooooh, Big Tiny, here he comes. He's soooooooo cool.'"

So Big Tiny was kind of like a chicken rock star, among a certain set anyway. Clearly, he had no intentions of taking his show on the road. But here's the thing: He never let his superiority go to his head, and he didn't take the affection of his flock for granted, either.

Big Tiny was inherently generous, and it was perhaps this as much as his sturdy good looks and cool unflappable demeanor that recommended him to every hen on the place.

According to Sue, he had a habit of finding tasty tidbits, or being the first one at breakfast, lunch, or dinner.

As he checked out the menu, he made little chortling, *tuk-tuk-tuk* murmurs to signal, "Chow looks good . . . all is well in our world."

So the hens, assured of safety and something delicious to eat, would come running. And gallant Big Tiny would step back until everyone had eaten her fill.

Clearly, this food and safety signal that brings hens running is a useful thing to

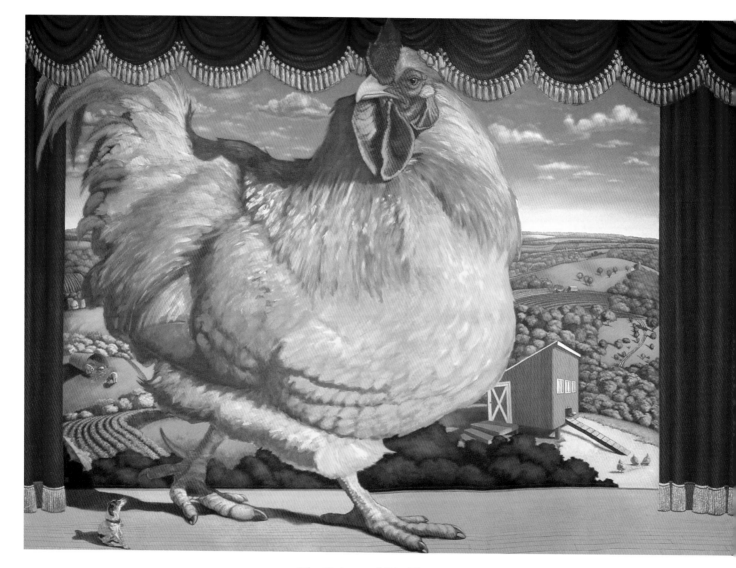

The Return of Big Tiny

know, if you're a rooster. Suffice it to say that Big Tiny saw lots of enthusiastic action.

But not all roosters are created equal, or equally good. Sue says some roosters make this distinctive food vocalization, and when the hungry girls come running it's all too clear these guys aren't advertising a nice caterpillar or some corn. "Forget the food, I've got something else in mind for you, my pretty," they say.

The hens, because they're chickens, and not given to much logical thinking, rise to the bait every time. Nonetheless, it doesn't make them like or trust a deceitful rooster.

"I have a friend who won't let a rooster on her place," Sue continues. "She says all they want to do is rape her hens and cause trouble for everybody else. But she never met Big Tiny."

Dexter, from The Return of Big Tiny

Cluck's in a Name?

"Don't count your chickens before they hatch," is an ancient saying. It was first written down in "The Milkmaid and Her Pail," one of the stories in *Aesop's Fables*, about 570 B.C.

•

No one knows the origin of the joke "Why did the chicken cross the road?" It first appeared in print in 1847 in *The Knickerbocker,* a New York monthly magazine.

•

Chickens coming home to roost, meaning that someone's bad actions are repaid in kind, first appeared in print in 1810 in a poem by Robert Southey called "The Curse of Kehama": Curses are like young chickens: they always come home to roost. An earlier version, "birds coming home to roost," goes back at least to the Middle Ages.

•

Cowards have been called chickens at least since Shakespeare's time:
"A rout, confusion thick, forthwith they fly, chickens"
—William Shakespeare, *Cymbeline*, Act V

•

Contrary to the well-known phrase 'As rare as hens' teeth,' researchers at the Universities of Manchester and Wisconsin recently found a naturally occurring mutant chicken called Talpid that has a complete set of choppers.
—*ScienceDaily* (Feb. 23, 2006)

•

The English word *chicken* may come from the Sanskrit word *kukuth.* In Old English, *cicen* meant a young fowl.

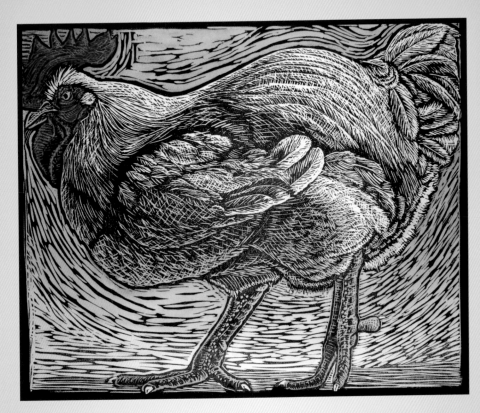

Cornish Cock (Before)

TASTES LIKE CHICKEN

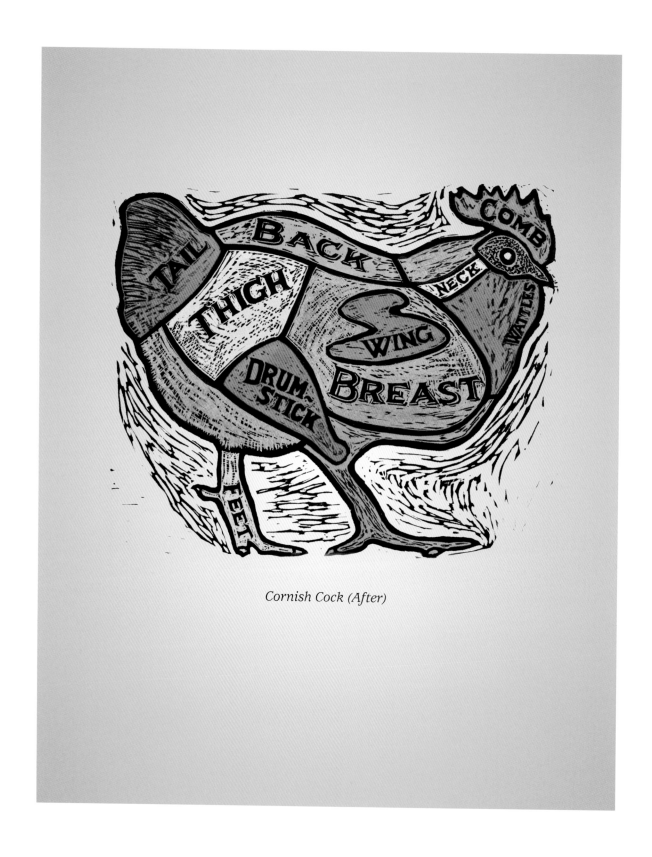

Cornish Cock (After)

Agents of the Dark

Is there anything that walks, crawls, or flies that doesn't like to eat chicken?

You wouldn't think so if you followed the comments on the many Internet sites devoted to backyard poultry and the people who love them. While snakes, rats, weasels, cats, owls, mink, possum, fox, skunks, hawks, bobcats, and coyotes all get their due attention, when it comes to the pantheon of chicken predators, there is one critter that routinely seems to evoke the greatest frustration and anger among poultry fans.

That creature is the raccoon.

With their nimble, incredibly clever hands, genuine intelligence, powerful jaws, and constant appetite, raccoons are prepared on a moment's notice to make McNuggets out of your chickens. Combine their voracious nature with their abilities to open locks as well as climb over, dig under, or tear through darn near any fence, and you have a most formidable foe for your fowl.

It's not just their effectiveness as predators that puts the raccoon at the top of many people's hate list. It's how they do their business.

Martha describes an all-too-common story about her family hen Super Chick, who lived with her sister, Girr, in a nice city chicken coop, just a few feet from Martha's bedroom window.

The hens always slept sweetly snuggled together, Super Chick often protectively positioned over her smaller sister. One night a raccoon slipped its strong, dexterous hand into the cage and managed to hook Super Chick off her perch. In a flash, the raccoon had dragged the hapless Super Chick partially through the wire, just far enough so it could neatly bite off her head. Mind you, it was just her head. Martha and her children found Super Chick's headless corpse in the coop in the morning, along with the thoroughly traumatized Girr. So stealthy and efficiently murderous was the coon that Martha had heard neither squawk nor death squeak during the night.

Contributing to the raccoon predation problem is the fact that coons thrive in most of the same environments as backyard chickens—suburban areas and hobby farms with lots of woods and brush make ideal habitat. So do cities with storm sewers as hiding spots and garbage cans to raid. Raccoon population density varies widely depending on conditions, but in prime habitat, they generally average about one per forty acres. In older residential areas where food is abundant, there may be twice that many, or considerably more. No one really knows.

Raccoons also top the enemies list because they are smart enough to find a way

into even the most locked-down chicken run. In one famous study, raccoons were able to open eleven of thirteen complex locks in less than ten tries and had no problem when the locks were rearranged or turned upside down. They can remember the solutions to tasks for up to three years, and once they find an easy source of protein, they're relentless in their pursuits.

Consider the sad story of Bob's many chicks.

When his daughters were young, he thought it would be a good idea to integrate the girls into the work of the farm by giving them some chickens to raise. He strung up some chicken wire in the hayloft of the barn and stocked the makeshift pen with twenty-five chicks he'd ordered through the mail. Next morning, when he went to check on the chicks, there was "nothing left but beaks and feet."

Being a determined sort, Bob next bought enough rolls of chicken wire to stretch the cage up to and over the barn beams, creating a fully enclosed sanctuary for the next batch of twenty-five chicks. The birds arrived, only to suffer the same total loss the next morning. This time, however, Bob thought he found the culprit. The barn cat was sitting near the cage, licking her lips.

Now, I don't know what other cats may do, but we live with a cat named Spencer who considers himself, for good reason, the world's greatest hunter. Moles, voles, gophers, rats, and rabbits live in terror. But even Spencer couldn't finish off twenty-five chicks in a single night. I suspect a raccoon did the damage and left the cat to take the fall.

And Bob? Well, he was determined. He added yet another layer of wire and repaired the hole where the killer had gotten in. Then he ordered yet another twenty-five chicks. The good news is that the third time was a charm; the birds survived and thrived in peace and security, tended carefully by the two little girls and their cats.

The war between chickens and raccoons is a piece of the conflict between agriculture and the natural world, or what passes for the natural world in our time of nearly ubiquitous human presence on the land. It's been going on at least since raccoon populations started to explode after the 1940s.

We aren't going to win that war no matter how many battles we fight. But that doesn't stop us from trying, and from talking endlessly about it with our neighbors and our chicken-loving friends.

Oh, Possum! Oh, Ick!!

There's something uniquely horrifying about the notion of being eaten alive. It's probably at the root of the terror many people feel about sharks. For a chicken, a possum fills the same terror territory, except that they usually are attacked while they sleep. It does seem a particularly gruesome way to be awakened, the most unappealing sort of alarm clock.

For a hungry possum, biting terrified, flapping chickens isn't a sport, as it often is for the family dog or any of the members of the weasel family, who appear to kill for pleasure as well as nourishment. Gruesome as its method may be, the possum is only after a chicken dinner. The killing part, actually, is incidental.

If a possum manages to gain access to the coop—these primitive mammals may look awkward but they're actually excellent climbers and far smarter than they appear—that snoozing chicken on a roost looks and smells like a living, breathing meal. It's likely to be good for at least a couple of fast, tasty mouthfuls, grabbed from meaty parts including the abdomen, neck, breast, or legs. If enough initial damage has been done, the possum may get considerably more than just a few bites. If those initial injuries prove fatal, the possum will happily eat the whole bird.

But if the first few bites don't inflict lethal wounds, the chicken may survive to roost another night, or even lay some eggs. Take the example of Judy's sturdy little hen Goldie, who lost her plump rump one night to a possum that reached into the coop and dragged her up against the wire. Then it began gnawing on her backside, as she frantically struggled to break free. Gravely wounded but not dead, she presented a pitiful sight when Judy found her, huddling in a corner, the possum scuttling away in the dark.

It took a lot of antibiotic ointment, many weeks of medical attention and tender care in solitary confinement, but Goldie survived. She even continues to be a regular producer of fine eggs. But Judy reports that sitting in the nest box now seems a little harder for Goldie than it used to be.

For the most part, chickens during daylight hours, going about their business of scratching, pecking, and checking out the world, aren't much of a target for possum predation. Attacking a conscious bird is just too much work and trouble.

But at night, all that changes, and the dark-loving possum gains the advantage over sleep-drugged chickens.

While eggs and young chicks are most vulnerable and most likely to succumb to a possum's appetite, even adult or mostly grown birds who have gone to roost and fallen into that deep, almost trance-like sleep face danger if their coop isn't secure.

An eager omnivore with an appetite for everything from carrion to rotting fruit,

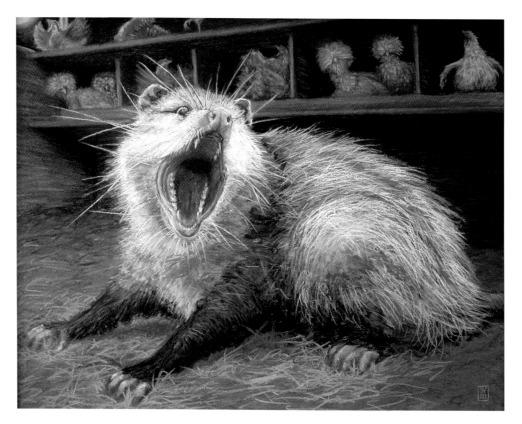

Trapped

earthworms to eggs, the nocturnal marsupial has a sharp dental arsenal with more teeth in its narrow jaw than any other land mammal and some unsavory habits that help make it a great evolutionary success story, similar to Wall Street traders.

Fierce when cornered, the possum can bewilder enemies by assuming a rigor mortis–like pose when danger threatens. When a possum plays dead, it's a remarkably effective performance involving considerably more than just lying still. The critter also may froth at the mouth, its jaws locked and tongue protruding. As if this isn't a sufficiently horrifying spectacle, the possum has another trick up its, ah, sleeve. It further repels any still unconvinced enemies by exuding a horrible odor, emitted from the anal glands. With talents like these, who needs speed or stealth?

The Birds of the Air

Other than skunks, possums, or raccoons dead on the road, most predators that lurk around us are inconspicuous. Foxes, coyotes, snakes, and weasels may be watching us, but we rarely see them.

One exception is the hawks. If you live in a rural area, or even most suburbs, it's not uncommon to hear the screech of a pair of hunting red-tailed hawks and to see them tracing their graceful gyres as they methodically scan the ground for prey.

But what if the prey they spot is your flock?

The first line of defense against airborne attack is the same as for the terrestrial variety—secure confinement. In the case of hawks and owls, that means completely covering your chicken run in wire or mesh, which may or may not be a practical suggestion depending on the size of your run.

If you want your birds to roam freely, you may have to accept some predation.

Shooting is not an option. The federal Migratory Bird Treaty Act strictly prohibits the capture, killing, or possession of hawks or owls without a permit.

Although no permits are required to try to scare hawks or other birds of prey, if you've ever used a scarecrow to protect your garden, you know, ultimately, the birds will win. Some people recommend flashing lights or firecrackers, but you may frighten your own flock of chickens in attempting to intimidate any winged aggressors. Other suggestions include stringing wires across the run or hanging old CDs from posts or trees so they flash as they turn in the wind. Whatever strategy you choose, it's likely that predators will learn to ignore it.

Fortunately, only a few hawks and owls present a significant danger to full-grown chickens, although chicks, young birds, and small chickens can be vulnerable to virtually every bird of prey. The great horned owl is the most dangerous of the owls; birds like screech owls and barn owls prefer smaller prey. Among the buteos, big, strong red-tailed hawks are the most likely predators with a taste for chicken. Among the Accipiter family of hawks, the goshawk is a bold predator that may be attracted by free-ranging poultry. The goshawk is relatively rare, although you will find that no consolation if one gets at your birds in an explosion of feathers and shrieks as the hapless chicken is hoisted off its feet and into the sky.

Cooper's hawks will sometimes deftly pluck a songbird right off your bird feeder, but they only occasionally cause problems with poultry, possibly because chickens are often larger than they are. But that may not stop them from trying.

The Plucking Tree

Gilbert tells of watching a young, inexperienced Cooper's hawk try to pounce on some of his birds.

Initially, the hawk perched in a nearby tree and several times swooped close to the chickens without striking. All of the birds except one scattered, flattening into tufts of tall prairie grass. The lone chicken to ignore the hawk continued scratching and feeding, apparently unconcerned by any danger. The now somewhat perplexed hawk perched on the pipe for Gilbert's septic system, not far off the ground and not far from where the cheeky chicken was checking out bugs.

Eventually, the hawk landed and followed a few inches behind the big hen. Gilbert says you could almost see the young hawk trying to do the calculations in its bird brain.

"Hmmmm. Where do I grab it? How heavy is that thing, exactly? If I grab it and try to fly, will I be grounded? Is this actually a good idea?"

Dodging this way and that way, seeking a reasonable plan of attack, the hawk clearly was in a dance of frustration. The game of cat and mouse didn't seem to register at all with the chicken.

Finally the hawk shook itself and flew away, perhaps hoping none of its fellow raptors had seen this humiliating hunting display.

Man's Best Friend; Chickens' Worst Foe

One of the most effective ways to keep raccoons, foxes, and other varmints out of your chicken house is to employ a guard dog. After all, from prehistoric times, dogs have been man's first line of defense against prowlers of every description.

Border collies, Australian shepherds, and even Jack Russell terriers are breeds that may have the requisite attitude and aggressiveness to set up an effective olfactory, auditory, and, if necessary, dental barrier between the wild world and your flock.

Only problem is, dogs are also among the worst poultry predators themselves, ranking only behind raccoons on the register of notorious chicken killers.

Sadly, a Google search of the term "dogs killing chickens" turns up more than half a million responses. Feral dogs, the neighbors' dogs, and even our own dogs are capable of wiping out a flock in minutes. And, even worse, it's not usually because they're hungry; it's just for fun or perhaps because prey-drive has gone into hyper-drive.

Even a dog who seems indifferent to a hen pecking peacefully in the garden may turn into a toothy terror if she starts to run, flap, squawk, fly, or engage in any one of the dozens of other provocative poultry behaviors.

Canine predation is such a common problem that there's a whole underground of folklore dedicated to ways of training your dog to stop killing chickens after he or she has already started. Invariably, the first step must be an assessment of just how much you value the dog and how far you're willing to go to set up boundaries between your birds and your dog's mouth. In short, when it comes to dogs biting chickens, no remedy appears foolproof.

One of the oldest, most common, and still most bizarre recommendations is to tie the recently killed fowl around the dog's neck until it rots, which is said to take five to seven days. Obviously, the dog needs to be segregated from other dogs and humans during that period.

But does it work? After an experience like that, I'm sure I'd be inclined to keep my dog far, far away from chickens just so I didn't have to go through the process of dealing with a rotting chicken carcass ever again. Whether dogs would actually care is another thing, given their proclivities toward rancid things.

Weird as it is, the idea has stood the test of time, harkening back to Samuel Taylor Coleridge's famous poem of the sea, *The Rime of the Ancient Mariner*, published in 1798. In the poem, the sailor who kills an albatross, which was regarded as an omen of good luck, is punished by his shipmates by having the bird hung around his neck:

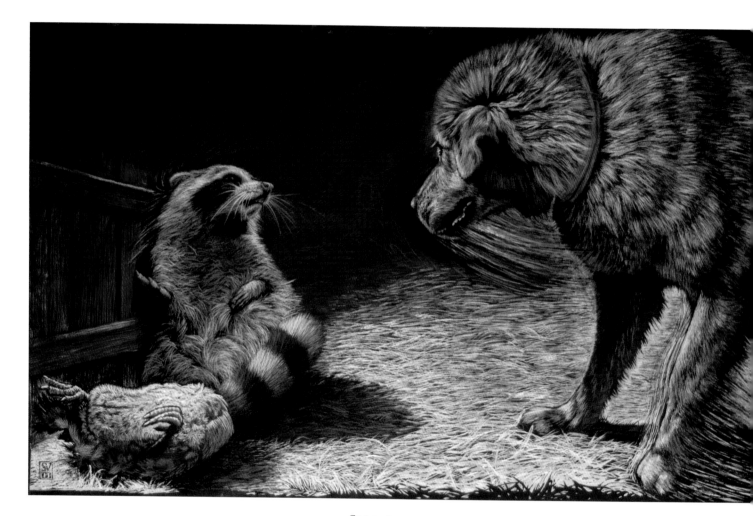

Consequence

Ah! well a-day! what evil looks
Had I from old and young!
Instead of the cross, the Albatross
About my neck was hung.

Sometimes dogs are not so much bloodthirsty as just curious—in a deadly sort of way. Sara had a brood of chicks she let range freely in the yard along with their attentive mother hen. Initially, she counted fourteen of them following the hen. The next day, she counted thirteen. By the time the count got to eleven chicks, Sara figured it was past due to keep some kind of watch herself over the baby birds.

Soon mama hen appeared, dutifully trailed by her chicks . . . and Oscar, Sara's half-grown dog. As she watched from the window, Oscar calmly picked off the caboose of the little chick train. Down the hatch, mystery solved. But only ten chicks survived.

In the end, there's really no solution other than separation, dog trainers and chicken fanciers agree. Good fences make good neighbors. What works for us may be best for our animals, too.

Best Dog in the World

We love our dogs.

But we also recognize that no dog is perfect. Our Doberman is as gentle and generous as the day is long, but also spoiled and selfish. (Hmmm, I wonder how that happened?) Our other dog is a Border collie, Texas heeler mix. He's calm, stoic, fearless, and an excellent listener—except when he gets some other idea in his head, which might involve chasing a deer through the woods or wading into the creek to pull a muskrat out of its den. He has a small jaw and unimpressive teeth, but he's fearless in using what he's got. His name is Joe.

Our dogs are friendly with people and usually trustworthy around animals, even the cats, although they don't mind chasing sometimes just for fun. They share all the usual canine instincts, so they aren't automatically well behaved. But over time, they've learned which animals are off limits, unless it's just too, too tempting.

When we got our chicks, we knew we'd have to be absolutely vigilant until the dogs learned that chicks aren't prey. That doesn't come naturally to a dog because chicks—and chickens—tend to behave in ways that seem specifically designed to trip the aggression trigger of even a golden retriever. The chicks stayed in a cage in the garage with the door closed until they were old enough to go into their combination coop and run—an eight-by-eight-foot enclosure solidly built of lumber and welded wire. It was designed mostly to keep out raccoons. We weren't thinking about dogs when we built it, but we should have been.

We knew Joe would be curious when we finally put the chicks out, and maybe even a little aggressive. Even so, we were utterly unprepared for the savagery of his reaction. He went after the chickens like an angry Terminator. When we weren't looking, he clawed at the wire until his paws were bloody. He tried digging under the fence. When that didn't work, he attacked the two-by-fours and ripped large splinters off them with his teeth. The barrier held, but if chickens can be psychologically scarred, ours certainly were.

There was plenty of yelling from us, and plenty of chagrined tail wagging from Joe, after we found the damage. But we knew it probably wouldn't do much good anyway, knowing there's a fair amount of truth in the famous Gary Larson cartoon, the one where the angry owner is yelling at the dog, but all the dog hears is, "Blah, blah, blah, Joe. Blah, blah, blah, bad dog. Blah, blah, blah."

Joe is smart enough to know we disapproved, and what we were mad about, but he is also single-minded and persistent enough not to care. After that, he was quiet as a lamb when we were outside with him. But for

weeks, if we turned our backs for a few minutes, he was growling and snapping at the chicken cage and testing every corner for a way to get inside and slaughter those chicks.

Now, with chickens grown, and a fenced run behind the chicken palace, we have the sense that Joe's become more accustomed to the birds. But still, we know we can never leave him alone with them.

Despite it all, we love Joe as much as ever, and we even trust him in a way—if trust can be described as predictability. We may not be happy with what he does, but we can predict how he will act and it's our job to take that into account. A lot of human relationships aren't so different.

Roll with a View

Sizing Up the Situation

In the Matter of Cats and Chickens

Jane Hamilton

I can understand many things about being a chicken. I get wanting to lay an egg. And how pleasant it would be to hop up into a wooden box plumped with hay, a box that's dark inside and quiet, and, for a while anyway, no one is going to bother you. Who wouldn't want to be free range, poking around here and there for good grub, not to mention seeing the world?

You'd go out in the morning after you'd been in the box for your quiet time, and you'd visit your old haunts, the places you remember having great stuff: the beetles in the zinnias, the worms in the soft patch under the lilac tree, the spillage by the compost heap.

What's this? A curious clot, very yellow, a little rubbery on the English muffin. This rings a dim bell in your solar plexus, but also, sweet Jesus, there is bacon! These people and their breakfasts!

It makes sense, that, as in all of life, there are the cool girls and the dorks, and it is to the hens' credit that everyone seems to know where they are in the order, although the question is occasionally asked by a whippersnapper, a young upstart: Am I cool now?

Now? Now? *No*, comes the answer, *you are not cool, and you won't ever be*. Although at some point, just as in life, occasionally those dorks, if they wait around long enough, do get to be the It girls, finally blossoming.

What I don't understand is why chickens allow themselves to be murdered, and sometimes wholesale, by hawks, foxes, the idiot neighbor dog, raccoons, and even, it has been said, possums. Why do they stand for this genocide when they are perfectly capable of bewitching cats, every last one of them? What's going on? A single hen has the power to psych out the twenty-seven cats in our barn so that none of them, not the strongest, baddest, ripped-up Tom, will even think about taking out the dear little mouthfuls that skitter around after their mothers. Tell me why a chicken can outfox a cat but not a possum, that sluggish beast with the terrible red eyes that should be a pushover.

The only thing I can figure is that the chicken's bluff must drive straight to a cat's deepest fear. Long ago, in the wilds of Mesopotamia, there must have been a flock of enormous bird-women who tore the kitty cats to shreds. The show of violence now, the great

wings flapping, the specter of the hooked beak, those horrid three-pronged feet, must make the noble and crafty feline forget its own claws, its own fangs, its own nimble ability to pounce. The hen's display must make the cat forget its own self, which is perhaps the worst by-product of violence. Maybe the other animals, those who freely dine on the chicken, have no communal memory of the bird-women, or maybe they are hungrier, or maybe the chickens have their own post-traumatic stress experience with the dog, the 'coon, the possum, and thereby are rendered powerless in an attack. I remain confused. All this to say, we once had many chickens and now have no more.

Our cat population remains somewhere between the ever solid twenty-seven to thirty-eight.

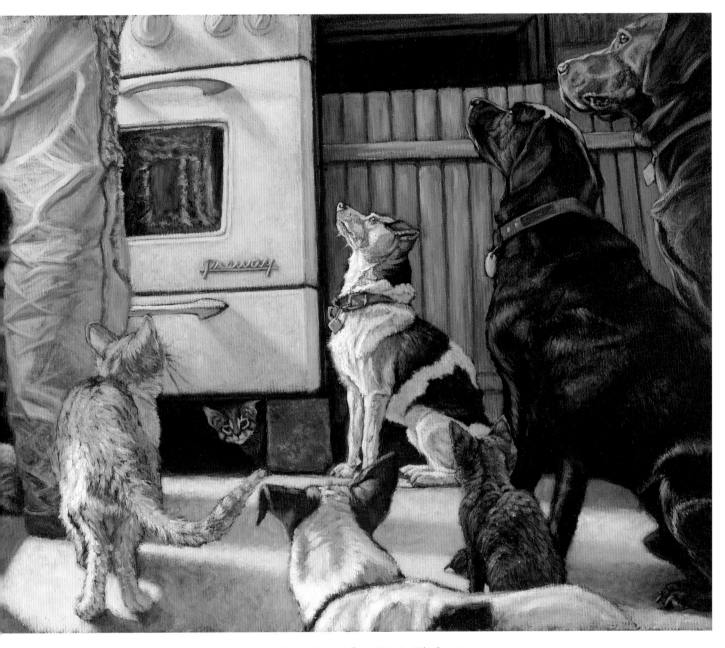

Farm Breakfast (Pat's Kitchen)

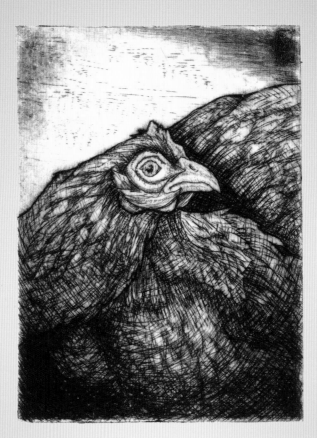

Cheeky

PLUCKY CLUCKS

Plucky Clucks

It doesn't take much to create pandemonium in the chicken coop.

Panic can ensue from any number of scary things, real or imagined. The shadow of a hawk, a barking dog, a floppy coat or a big hat or a pair of boots the hens haven't seen before, or maybe just a new shovel, sitting next to the wire run.

Legitimate threat or wacky worry, the response is usually the same. First a mad scramble of squawk and shriek, frantic alarm clucks going off. The birds sprint about, often loosening feathers as they awkwardly try to take flight, whacking into walls or windows or wire. It's a brief screech-fest as they crush through doors or gates, in or out of their house or pen in a wild dash for cover or what they seem to assume might be safety.

In a minute or so, it's usually all over and everyone's back to pecking and scratching, shaking their feathers and doing a little quick preening to prove they weren't all that scared, after all. Besides, it's already in the past.

It can be exasperating. Then those familiar, pejorative terms come to mind and mouth: Flighty. Dumb clucks. Chicken hearted.

But as I've come to know this bird-brained behavior, I remind myself that, if you're a chicken, the world truly is full of danger. As the saying goes, just because you're paranoid doesn't mean they aren't out to get you.

And I remember that chickens can also be remarkably resilient, tough, even brave in the face of enemies, odd as it may seem. Some of my favorite stories prove the point that chickens can be plucky.

Consuela May

If you've ever been in a modern landfill site, you know it's a pretty scary place. It's an almost lunar landscape, a vast, unappetizing trash desert, filled with all that's broken, discarded, and decaying from a consumer culture. Enormous, rumbling earthmoving equipment pushes mountains of unidentifiable scrap around, a toxic mix of garbage and junk, buried in foul-smelling dust.

A particularly grisly kind of trash—hundreds of thousands of dead, spent layer hens from egg factories—routinely is dumped into landfills. That's how a little white layer hen, who came to be known as Consuela May, found herself in the Deer Creek landfill site near Jefferson, Wisconsin.

But she wasn't dead. When Liz and Garrett first saw her—looking bloody, dodging huge trucks and other equipment, and weakly pecking through the debris—she didn't look like a particularly lucky chicken, although she had somehow survived being both gassed at the egg factory and dumped from a truck in the landfill.

"We were dumping roofing debris when we saw this little white thing, moving among the piles of trash. At first, I thought she was a plastic bag or some paper, kind of blowing around," Liz recalls.

Liz is the kind of animal lover who routinely travels with a dog cage in the back of her truck, just in case she comes across an injured or abandoned critter. So she was well prepared to try to rescue a hapless chicken in a most inhospitable spot.

It wasn't all that difficult to capture a dazed, thirsty, exhausted little hen. What Liz initially thought was blood all over Consuela's shoulders turned out to be sunburn. And although the bird was weak and painfully thin, a vet told Liz she was basically healthy, despite her ordeal.

Within a couple of months, her feathers had grown back. She had settled happily into a backyard coop with a companion chicken she liked. She started regularly and enthusiastically laying perfect eggs, one every day. Apparently she hadn't read the factory poultry manual that said she was spent, or maybe she was just grateful for the new lease on life.

And she became famous. I wrote about her in a news story for the *Capital Times*, and shortly afterward she and Liz, her rescuer, were invited to be part of a feature length documentary film called *Mad City Chickens*.

As one of the stars of the show, Consuela has handled being a celebrity gracefully. Liz says she shows determination and calm aplomb in all aspects of her chicken life. I suppose you could say she was just lucky. But I think the term "plucky" is far more appropriate.

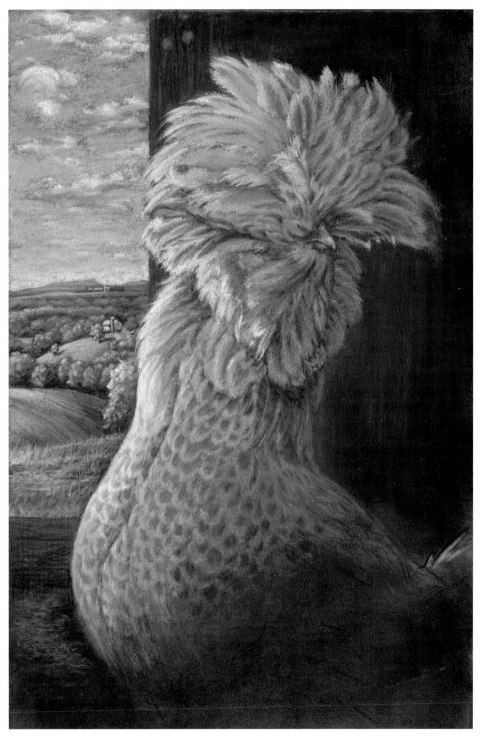

Portrait of a Pullet

Emmy Lou's Wild Ride

Bonita and Fredericka are proud flock mistresses of the Dixie Chicks. These pretty and productive laying hens, all with country diva names like Loretta, Patsy, and Dolly, provide plenty of eggs but also a high degree of amusement and entertainment, like most chickens who are known as individuals, not units of production.

These hens are not flighty little nitwits by any stretch of the imagination. But no self-respecting or self-preserving hen should be expected to stand her ground and stay calm when a visiting dog decides it's time for a rousing game of chase-the-chickens. Needless to say, as the ill-mannered bowser Bert barked and lunged, yelped and pounced, the Dixie Chicks hastily headed for the hills and beyond.

Naturally, Tim and Maria, the two-legged visitors who introduced this pooch with poor manners to Bonita and Fredericka's farm, were mortified and chagrined. But they were also relieved to see no evidence that Bert had managed to kill or seriously damage any of the girls. The disgraced dog was placed, firmly, in the van he arrived in. An all-hands-on-deck chicken roundup began.

After a long, intensive search and some serious chicken wrangling, all but one of the Dixie Chicks were found, recaptured, and returned to their coop, none the worse for their big scare and scattered flight. But Emmy Lou, a little Rhode Island Red hen, was still missing.

Tim and Maria bade an apologetic farewell and turned the van homeward. Bonita and Fredericka, hoping that Emmy Lou would return home once the offending dog was gone, kept scouring yard and garden, field and woods. Alas, still no red hen.

Meanwhile, Tim, Maria, and Bert arrived home, about ten miles away. It had been a rather quiet, mournful trip, with two stops—one at the town hall, the next at the post office. Even Bert, normally an enthusiastic sort of puppy, seemed chastened.

As Tim and Maria marched indoors, Bert slunk behind them. He may not have known precisely what the offense was, but he knew he was in the doghouse.

When Maria turned to shut the door behind her pup, she saw something small, quick, and reddish brown out near the van. Then it darted under the lilac bushes. It looked like a chicken. Darned if it didn't look surprisingly like one of the Dixie Chicks.

Back at the ranch, there was still no sign or sound of Emmy Lou. Then the phone rang.

"I have no idea how she got here but I think maybe we've got one of your chickens," Maria said. "And she doesn't want me to catch her so maybe you should come," she added.

Emmy Lou? Ten miles down the highway? It sounded like a long shot but Bonita and Fredericka dutifully got in the truck to check out the bird in the bushes. By the way, ten miles is a long way for a chicken to fly. Even farther to run.

When they arrived, they found that the chicken under the lilacs at Tim and Maria's did, in fact, look remarkably like Emmy Lou. But she was clearly not enthusiastic about being caught, by dogs or people or anyone else. Dashing through the lilacs, hiding under the van, she dodged her would-be captors for nearly an hour.

Bonita, panting, finally was able to grab the elusive hen. This chicken, eyes now tightly squeezed shut, was either Emmy Lou or her exact stunt double. But how did she travel to Tim and Maria's?

Clearly, she hadn't ridden in the van with Bert. And there was nowhere on the back, front, or sides of the vehicle where she could have grabbed hold and hung on. The only option, unlikely as it seemed, was that

Emmy Lou had jumped up under the van, perched on an axle, and somehow managed to stay put during the wild, dangerous ride to Tim and Maria's.

In the cab of the truck on the way home, Emmy Lou tucked her head under Bonita's arm and seemed to fall asleep, content to travel in a less dramatic way.

"But why didn't you hop off at the town hall?" Bonita asked, stroking Emmy Lou's feathers.

"Or the post office?" Fredericka added. "She'll probably never lay another egg," she sighed as she looked over at the snoozing hen.

The next morning, however, Emmy Lou strutted into a nest box as if nothing had happened and proudly produced an egg. It wasn't even scrambled, Bonita and Fredericka reported.

But as far as they know, Emmy Lou has shown no further inclinations to perch on an axle. And she still doesn't like dogs.

Buffy Lays an Egg

Buffy and Zelda, two of our original Buff Orpingtons, now live in a converted rabbit hutch in our daughter's grassy urban backyard, which they share with two large, rambunctious standard poodles, Sophie and Sebastian.

Sebastian is still a puppy, but an enormous puppy. At almost seventy pounds, he looks like a large Muppet, loopy and exuberant with paws the size of dinner plates. He's one of those dogs that's always laughing, his tongue lolling out of his mouth as he gallops around, looking for trouble.

Even for an elegant, rangy breed like the standard poodle, Sebastian is tall. So tall, in fact, he's kind of like a guy in a dog suit when he stand on his hind legs and throws his front paws over your shoulders. Not that he's encouraged to do that, mind you, but he could, and, once in a while, he does.

And though the former rabbit hutch stands four feet off the ground, Sebastian towers over it when he wants to peer into the hens' nest box. To the hens, I imagine he looks kind of like some curly-haired, window-peeping King Kong.

During one particularly exciting day in the yard, Sebastian threw himself against the cage with enough force to lift it off its base, providing a hole big enough for Buffy and Zelda to escape. If dogs can shout, I imagine Sebastian's was a quick "Hallelujah!" as the frantic hens fluttered right into his waiting jaws.

Naturally, screeching ensued and our daughter Julia was on the scene within seconds. But the unlucky Miss Buffy was already limp and bleeding. Sebastian, having discovered the most fun toy he'd ever encountered, couldn't be called off. Julia finally got a neighbor to grab the frolicking dog while she retrieved what she was sure was Buffy's carcass.

But, no. The adolescent hen's eyes were squeezed shut, but she was breathing. She'd lost some feathers and had some bloody scratches on her neck. As Julia tenderly held her, she began to stir, finally summoning the courage to open her eyes again and look around. She didn't object to being cleaned up, and she didn't fight a bit of medical attention.

Cottage cheese and some dried cranberries had a restorative effect, and after an hour or so she seemed more than ready to return to the coop, which was newly reinforced to prevent further predation.

There is a happy ending to this story: Buffy laid the first egg of her young life a few hours later, and has continued to lay

reliably on a daily basis ever since. Six weeks later, her sister still had produced no eggs. Perhaps Buffy's close encounter of the doggish kind made her aware of her mortality, encouraging her to get on with the business of life, or perhaps her experience of shaken chicken syndrome simply shocked her system into action.

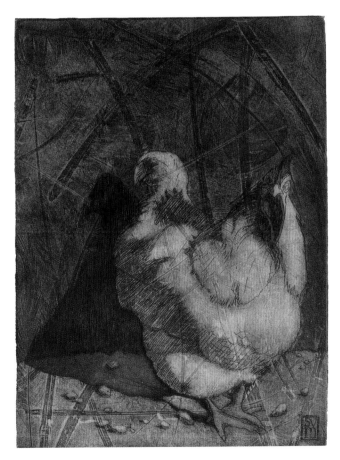

Big Tiny Crosses Over

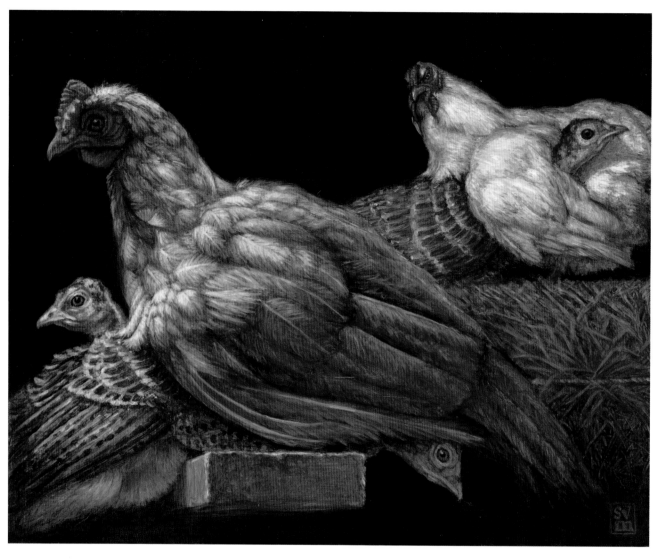

Maternal Instincts II

Maternal Instincts—Madonna Mama Hens

When it comes to caring for youngsters, chickens are a little like people. In other words, there's a wide range of maternal behavior.

Some hens not only are devoted to their own downy, adorable children—hence the affectionate term "mother hen"— they also may be perfectly happy to care for the neighbors' kids, too. These nurturing avian souls are reliably "broody," interested in sitting on and hatching eggs at regular intervals, and are usually responsible, affectionate, protective mothers once their chicks hatch.

On the other hand, there are also plenty of chickens who have little interest in the demands of motherhood, perhaps aware that egg or meat production, not raising the next generation, is their claim to fame. These girls are the kind of chickens who could wear the buttons that read "Oh, no. I forgot my baby on the bus!"

For anyone who wants to raise some chicks, a broody chicken who enjoys the tasks of chicken motherhood is a treasure. Such a hen can often be persuaded to raise some other more unusual offspring, too, with some inadvertently hilarious results.

There are loads of examples, but Sue Medaris has one so distinctive it inspired a painting.

Her flock of farm chickens earn their keep, and she's quick to tell you these aren't pet birds. They provide an endless source of inspiration and subject matter for Sue's art, and they are also food sources, for eggs and meat alike. The other critters on her farm work, too, from the barn cats to the herding dogs to the pigs and turkeys. Pigs and turkeys, along with the chickens, help stock the freezer.

One summer, Sue had a particularly broody hen, who was thoroughly determined to hatch some eggs. Besides some chicken eggs, Sue also had some turkey eggs. Unfortunately, what she didn't have were hen turkeys interested in the work of getting their offspring hatched.

So she gave the big eggs to the chicken who was willing to care for them. Dutifully the hen looked after her own eggs and the turkey eggs, too, showing no favoritism.

When the chicks and the turkey poults hatched, mama hen welcomed them all.

From the beginning, it was amusing to see her tender interest and total devotion to her mismatched family, including the large foster children. But it was also a tribute to mother love, as the turkey poults grew, and grew, and grew. The hen never wavered in her attention, even as the poults began to rival her in size.

But the mother-child relationship in this unusual family went both ways, and if the turkeys ever had any questions about their parentage, they didn't express them. In fact, it appeared that the young turkeys grew up happy and well adjusted, feeling thoroughly confident that their petite mother could protect them from harm, particularly when they took refuge under her wings.

Never mind that they barely fit under the shelter, their heads awkwardly poking out. They were cared for by a mother always attentive to their welfare. Their obvious differences may have amused others. It mattered not at all to this happy, if eccentric, family.

And then there's the story of a heroic little Silkie hen, passed along by a friend of a friend of a friend. Given the reputation for dutiful mothering these pretty little birds have toward their offspring, it has an authentic tone.

The story is brief: She and her brood of ten little chicks were happily going about the business of scratching and pecking for food in a farm meadow near their coop, along with a mixed flock of about a dozen other hens and an alert rooster.

It was a sunny day, and when an ominous shadow passed over the flock, the rooster let out that loud, distinctive danger cry that tells his girls to run for their lives. Hens and chicks raced for cover, flattening under tall grass and brushy fencerow, hoping to elude an aerial hawk attack.

The raptor circled back, lower this time, to see if chicken tenders would be on his lunch menu.

Two confused little chicks, left behind, were peeping piteously, circling each other frantically, well aware that the warning call had gone out and they had somehow missed it. Their mother, hiding with the rest of her brood under some brush, darted out to the crying chicks, spreading her wings in a protective tent.

Little, pale colored, visible, the Silkie hen was an easy target. A moment later, the hawk circled again, this time diving down and grabbing the small hen, sparing the chicks who were saved by her sacrifice.

Did she know there was mortal danger? Obviously, instinctively, she did. But mother love and duty apparently trumped fear. This little Silkie may have been a chicken, but clearly she was no coward.

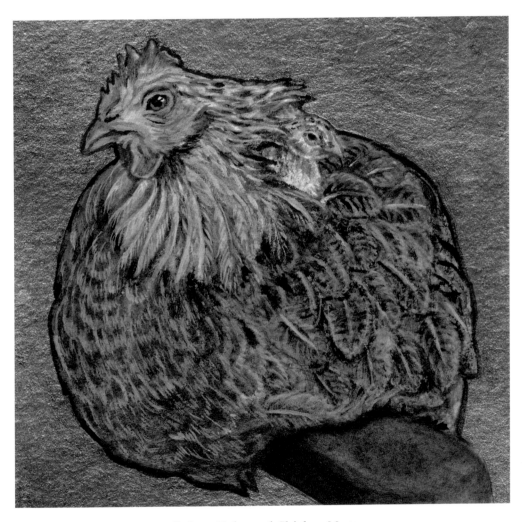

Guinea Babe and Chicken Mom

Broiler Hen Breaks Away

There's little that's sentimental when it comes to chickens on a working farm, even an emphatically organic farm like Vince and Dawn's St. Brigid's Meadow with its deep commitment toward responsible care of land and animals.

So when it's time to butcher the chickens, it's a respectful but no-nonsense business: Those broiler chicks that arrived less than three months earlier have been carefully tended and fed . . . and fed . . . and fed. These birds are the couch potatoes of the chicken world, with an inbred drive toward eating and lying around that makes them grow fast and quickly convert chicken feed into a nice plump, tender bird that's well suited to the human table.

As soon as the birds have grown to roaster or fryer weight, it's payback time for the food, shelter, and care—farm style. At their farm, that means swift, humane butchering and quick, business-like processing. Obviously, a practical attitude must prevail for the job to be done, so it's rare for there to be any hesitation in the action or change from the often practiced script.

But then there's the case of the broiler hen who got away.

Like her brothers and sisters, she ate a lot and grew fast. In one important way, however, this particular young chicken was surprisingly different from her fellow broiler birds. She had learned how to run, an ability and ambition missing in most modern meat birds. Fat, placid, and lazy, broiler chickens don't make a habit of breaking for freedom. Too heavy for their unsteady legs, most wouldn't get too far, anyway.

This young hen was an exception, bolting swiftly away from her would-be captors on butchering day. She was not only quick but apparently quick witted, too, taking refuge among the laying flock.

The first time she made her break, she was captured and returned to the killing ground.

However, when she got away again, running once more toward the life of a laying hen, her tenacity as well as her initiative and athletic ability didn't go unappreciated. This time she was given a reprieve from the pot, allowed to remain among the egg producers, where she'd have a chance to bring her unusual qualities to the gene pool.

❖

What's Your Sign?

The rooster is one of the twelve signs of the Chinese zodiac. People born in the year of the rooster (1909, 1921, 1933, 1945, 1957, 1969, 1981, 1993, and 2005) are thought to be deep thinkers, capable, and talented. They like to be busy, are devoted to their work and are deeply disappointed if they fail.

People born in the year of the rooster are said to be a bit eccentric, and often have rather difficult relationships with others. They always think they are right and usually are! They frequently are loners, and though they give the outward impression of being adventurous, they are timid. Their emotions, like their fortunes, swing very high to very low. They can be selfish and too outspoken, but are always interesting and can be extremely brave.

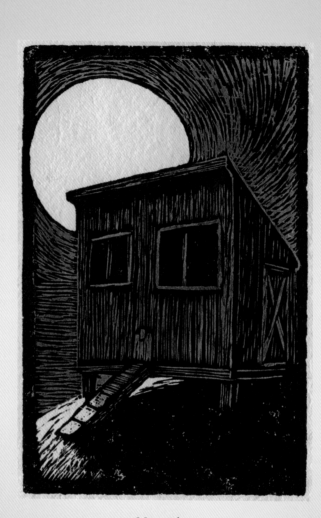

Moonrise

CREATIVE COOPS . . .

Chickens represent a triumph of human imagination. There are more breeds of chickens than there are breeds of dogs. Every size, color, and behavior has been tried and refined. In fact, the only thing that may eclipse the astounding variety of chickens is the galaxy of odd and imaginative chicken coops.

This variety is a result of the explosion in backyard chicken keeping. In the old days, every farm had a chicken coop and every coop looked about the same. The selection of red or white paint may have been about as far as creativity went in those days. Of course, when you were trying to milk thirty Holsteins by hand, or can three hundred quarts of tomatoes over a wood-burning Monarch range, creativity got spread around pretty thin. Not so today.

Everything from packing crates to old fiberglass pickup truck toppers and even those colorful plastic playhouses the kids have outgrown has been pressed into service. Some rival the mini-mansions so lately in vogue in the gated suburbs, with fancy windows, finely detailed carpentry, and designer paint colors to match the big house. Others are no more than collections of cast-off screen doors.

In fact, I suspect chicken coops are beginning to fill an important niche in the lives of American men. Much has been written about the supposed loss of manly vigor now that factory jobs have moved overseas and cars have become too sophisticated for most weekend tinkerers.

But a chicken coop. Now there's a peaceful, but challenging, project for anyone with a Skil saw and a carpenter's pencil. I must say, my husband has taken to chicken home building like a duck to water. Unlike projects in our actual house, this is not nearly such a source of frustration. Any off-center boards or

Going In

odd angles provide eccentric charm rather than embarrassed chagrin along with endless tweaking or reworking, usually accompanied by much swearing and the occasional (gently) thrown tool or two.

We refer to our coop as the poultry palace. Actually, it's more like a chicken cabin than a palace, but we consider it quite grand, at least by chicken standards. And besides, we have fond memories of the days when it was our daughters' wooden play structure on stilts. During those long ago years it was commonly used as a ropes course and climbing gym for active dolls as well as a home away from home for armies of stuffed animals.

Now the chicken run and shelter occupy that space among the oak trees just up the hill from our farmhouse. As our chickens' abode, it has been modified with raccoons and hawks in mind as much as chickens.

The perimeter is secured by oak boards buried twelve inches deep in the sandy soil and topped with two feet of hardware cloth, so not even a hungry coon could slip a paw through. Welded wire runs all the way to the top, where a solid wood floor is covered with a tarp to keep the rain out.

The fowl sleep in a plywood box attached to the side of the wire cage that is outfitted with nest boxes, perches, a double-layer wire floor, and exterior-access egg doors secured with heavy hardware. An old-fashioned barn window provides both light and easy access. The coop has multiple latches and locks, and if we remember to close them, they should befuddle all but the most ambitious predators. So far, so good. It's designed so that the sleeping quarters can be moved into our horse shed for the winter, where the chickens will stay warmer and their caretakers have easy access to water and electricity during the long, blustery Wisconsin cold season.

For now, the coop has become the place we have to show every visitor, whether or not they have expressed the slightest interest in chickens. We have to admit our chicken-keeping friends probably appreciate the experience more than the others. Here we can lean against the sturdy corner posts and kick around ideas about how to build a better coop, or exchange the latest chicken trivia.

And, speaking of kicking, if you're wearing your work boots, this is the ideal venue for doing a little dirt kicking. It seems to do a body good, and the chickens don't mind a bit.

Last Warm Light

Busted

WHICH CAME FIRST?

Eggstraordinary

Just as a Zen master has no problem contemplating the sound of one hand clapping, a new chicken owner may suddenly realize that the age-old question "Which came first, the chicken or the egg?" has an obvious solution. Anyone who has raised hens from chicks, and then waited . . . and waited . . . and waited! . . . for them to produce their first eggs understands deep in her impatient little heart that *of course* the chickens came first. And if those pullets don't hurry up and produce, they may wish they'd crossed the road before the stew pot was hot.

Even urban agriculturalists who treat their pullets like family pets are quick to tell the neighbors that the real reason for that fluttering flock of birds is eminently practical: It's all about "the eggs."

But then an odd thing may happen when that first egg—much anticipated—finally arrives, accompanied by much squawking and flapping. Rationally, we know the chicken's purpose, and our little farm venture, has finally come to fruition. We could hardly be prouder if we'd produced the egg ourselves. It's almost like a new grandchild, and it feels, ahem, far too precious, to actually eat. So that first egg—much discussed, much displayed and admired—often shares the fate of the first dollar earned by a new business. It goes on display for so long it may lose its value.

But here's the dirty little secret: Some of us discover that we don't feel quite right about actually eating that first egg. In fact, it makes us just a bit queasy. After all, it was recently *inside a chicken . . . our own chicken*. And we know their culinary habits can include any number of rather unappetizing elements, especially if they are out and about, foraging through dirt and dust and who knows what else for some tasty, obnoxious tidbit, like worms or bugs. And then, of course, there's that amazing, slightly alarming way it just comes popping out of the business end of the bird.

After a few days, egg laying becomes routine, and we know the resulting eggs are a delicious addition to the menu.

Initially, I have to admit, I found the entire experience—reaching under the hen, finding the egg, cracking it in a bowl, cooking it, putting the finished delicacy on a plate—a little creepy, as my daughter described it.

Even now, as we consider getting eggs from our own flock of chickens to be eggstraordinary, eggciting, and eggceptional, sometimes we need to dial down our sensitivities to thoroughly enjoy the results of our hens' labors.

Once we do, we're able to laugh at ourselves, and also laugh at the story my mother likes to tell about the squeamish shopper who goes to the grocery to buy her dinner:

The housewife goes into the market and asks the grocer to recommend an especially good meal for a bargain price. Her grocer suggests beef tongue as an economical, epicurean choice, adding, "This one is especially fresh and delicious!"

The housewife is horrified.

"Yuck!" she shrieks. "I can't possibly cook tongue and eat it. Why, it was just inside a cow's mouth!"

"So what would you like instead?" asks the grocer.

"Oh, just give me a dozen eggs," she replies briskly.

¡Ay, Mamacita!

CLUCK

Which Came First?

Ben Logan

The new warmth of spring meant the chickens could be let out to run free. When I opened the door for them, they poked their heads outside cautiously for the first time in four months or more, then with a wild flapping of wings they ran out into the yard.

"Just like you boys on the first warm day," Mother said.

The chickens chased and leaped and cackled for a few hours, then settled down and began scratching for seeds, eating the new grass, and looking for insects. Almost immediately they began laying more eggs. These eggs were different, the yolks much darker yellow. Mother's cakes were a richer color, and everyone said the eggs tasted better.

For me there was a problem in the chickens being let out. As far back as I could remember, I had been the official egg-gatherer. In winter I had only to go into the chicken house and reach into the nests for the eggs, sometimes doing it twice a day in the coldest weather so the eggs wouldn't freeze and burst. But starting with spring the eggs might be just about anywhere. Something about being free

brought out a secretive side of the chickens. At least half of them seemed determined to hide their nests from me. So with spring, egg-gathering became a battle of wits.

"All you have to be is smarter than the chickens," Lee said, laughing at me. "That shouldn't be too hard, even for you."

It was, though. Either I wasn't very smart or the hens were a lot smarter than most people figured. Any sporting hen is supposed to cackle when she lays an egg. We had hens that would lay an egg and run halfway across a forty-acre field before they'd cackle, some that laid eggs and never did cackle, and some that cackled and ran but never did lay an egg. With hens looking pretty much one like another it was hard to get very scientific about egg-gathering.

Some years we had two breeds of hens and that helped. The smaller white leghorn had a more excited cackle and liked to hide nests in high places such as the haymows. The heavier Plymouth Rocks stayed on the ground and had a deeper-voiced cackle.

Mother helped by observing. "One cackled down in the orchard today," she'd say.

"What kind of cackle?"

"Sounded like a Plymouth Rock."

That meant the hidden nest would likely be on the ground. But the hiding places on a farm were endless. Hens used the soft sawdust under the protruding ends of the post pile, sheltered fence corners, feed boxes of unused horse stalls, hidden corners of the haymows, and a hundred nooks and crannies in every outbuilding, weed patch, and sheltered spot.

They especially liked dark and secret corners. Where one week I reached in to find a fresh egg, the next week I might find the nest taken over by bumblebees. Once, poking into a dark tunnel in the haymow, I felt something cool and smooth. But the shape was wrong. I took hold and hauled back. Out came a hissing, five-foot black snake, lumpy with swallowed eggs. I jumped back. My full bucket of eggs and I went crashing down the hay chute. I don't know what happened to the snake (were the eggs inside him already broken?). Mother said it was the best job of scrambling since the time the buck sheep butted me when I was climbing over a board fence.

There was a time she may have forgotten. That was when I was coasting downhill toward the open barnyard gate, a bucket of eggs in the wagon with me. Just as I got to the gate, the wind blew it shut.

I remember once at breakfast when it seemed everybody was reporting cackling that I was supposed to investigate. I began to feel the whole purpose of the hens was to give me a bad time.

Father laughed at my grumbling. "Ever stop to think those poor hens are just following their natural instincts? Probably all they want to do is get a batch of eggs together and hatch out some chicks. So the smarter you get, the smarter they have to get."

"Actually," Mother said, "it's kind of a compliment to you. It shows they respect your ability."

Well, that may have helped my bruised ego a little, but it didn't make the nests any easier to find.

For every reported and suspicious cackle I had to set up a strategy. Fortunately, each hen tended to lay her eggs at about the same time every day. I would hide and watch for one beginning to move in the direction of the reported cackle. They were very good at it. A hen would keep pecking and scratching, as if all she had in mind was more food, and all the time be slowly moving off from the other chickens. I shadowed the hen, keeping out of sight, trying not to make any noise. Of course, a hen never went straight to her nest. There was some kind of "natural instinct" that took care of that, too. She'd move off in one direction, double back, go around buildings, head into the deep weeds. At some point when she was half hidden, she stopped being casual and I knew she was getting close. Crouching low to the ground, the hen would creep forward so slowly that I might lose her if I took my eyes off her for a second. Then, if I was lucky, she'd move to her nest and I had won.

I didn't always win. There were hens that seemed to know I was following them. They just played a game with me. They would follow the standard routine, moving off casually, then beginning to creep, but after about fifteen minutes of leading me on they would

walk out of the weeds and rejoin the other hens. Were they just practicing or did they know exactly what they were doing? I wanted to ask Mother if she knew of any way to tell if a chicken was laughing, but I couldn't think of a way to ask without giving away more information than I got back.

Sometimes hens were all too easy to outsmart. They overacted. I remember one who reminded me of how Lee and I tried to look very innocent when we were staging a raid on Mother's shredded coconut in the pantry. Sort of humming a little song, this hen would poke along toward the horse-barn door, acting as if she didn't have a thought in the world, or maybe was just out for a morning stroll. But she kept moving right toward the barn. Finally, with a little look, as though to see who was watching, she would hop through the door. About twenty minutes later she'd come walking out, still humming her little song. Slowly she would stroll halfway across the barnyard, and only then would she suddenly run and cackle. But I knew from experience that her egg would be where it always was—in the third horse stall from the door.

Other times, weeks went by before I located a nest. Then I'd find it, full of eggs. Such eggs were not to be trusted. I put them, a few at a time, into a bucket of water. If they didn't float, I took them to the house and put them in the basket reserved for what Mother called "the questionable eggs." Eggs from that basket had to be broken, one by one, into a cup for observation before they were used. For years I thought the phrase "don't put all your eggs in one basket" had something to do with separating good eggs and questionable eggs.

If the eggs floated, I either buried them or threw them against the side of the silo to see how they smelled. It was a way of checking the reliability of the water test. Usually they smelled pretty bad.

Sometimes a hen would be setting when I finally found the nest. Then I had to make a decision. How long had she been setting? Did we want more baby chicks? Was it too late in the season?

I had to sit down and think about it. If I took the eggs away from the hen maybe she'd stay on the empty nest anyway. Some hens were just natural-born setters.

One thing to do was see if the eggs were shiny. If they weren't, they'd been set only a few days and were worth putting to the water test. For the set-on eggs, the test was helpful but not conclusive. An egg that floated might be too old and going bad, or it might have a baby chicken forming inside. So when set-on eggs didn't sink, I had to run back and put them under the hen to stay warm while I made up my mind.

It was a weighty decision. How was the hen going to feel? Was there a beginning live chick inside each egg? I had to be careful about getting too sentimental. If I made a wrong decision too late in the season, there would be a whole bunch of little chicks running around in the frosty grass to feel sorry for. A late batch of chicks was always a mark of my failure, not easy to hide either, with chicks hopping and cheeping all over the place.

I can recall exactly how egg-gathering became a thing of philosophy for me. It was a warm spring day when I was in the second grade. All the boys were lined up at lunchtime, leaning back against the warm south wall of the schoolhouse. I carefully cracked a hard-boiled egg against the edge of the half-gallon syrup pail I used as a lunch bucket.

"Which came first, the chicken or the egg?" one of the big boys asked.

I hadn't been initiated to the riddle. I just stared at him.

"Which came first?" he repeated, laughing.

I thought about it. "The chicken hatches out of the egg."

"But the chicken had to be there already to lay the egg," he said.

I could see that all right, but where had that chicken come from if not from an egg? I sat there eating my hard-boiled egg, dipping it into the mixture of salt and pepper Mother had wrapped in waxed paper for me. The argument went on around me. The majority opinion was for the chicken being there first. Somehow chickens were more real.

I thought about it all afternoon. When I went out with my bucket that evening, I picked up a smooth white egg and turned it over and over in my hand. There was life in there. Inside that cool and motionless white egg, which made a silly hen cackle, was the start of a new chicken. And that new chicken would grow up, lay an egg and cackle, and the new egg would . . .

It was too much for me. I could see an unending line of eggs and hens stretching out of sight in both directions (I don't remember when I caught on to the importance of roosters). Still holding that white egg firmly in my hand, I went to consult Mother.

"Which came first, the chicken or the egg?"

She didn't laugh. She thought about it for a moment and said, "Neither."

She went over to my blackboard, next to the kitchen range, and drew a circle. "The chicken and the egg are both part of the same circle of life."

"Oh," I said.

I went back out and finished gathering the eggs. A circle was certainly better than a line. A circle stayed right where you could see it.

The next day at school I had a hard-boiled egg again and one of the boys asked me which came first. He started laughing.

"Neither one came first," I said. I picked up a stick, brushed the wood chips aside, and drew a circle on the soft ground. "The chicken and the egg are both part of the same circle," I said with great authority.

"Oh," the boy said.

Everyone sat there looking at the circle. No one ever brought up the question again. There's something about a circle that puts a stop to things. Maybe that's all that philosophers really do—just bend the straight lines into circles, the lines coming back to meet each other so there aren't any loose beginnings or endings anymore.

Now that I come to think of it, I guess my mother was a pretty good philosopher.

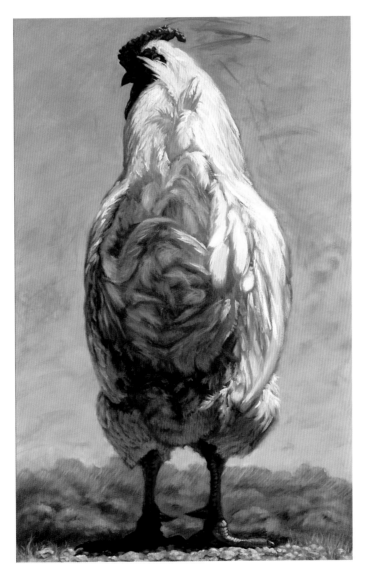

The Toughest

How to Hard-boil Eggs

I make hard cooked eggs the way my mother taught me: Put the eggs (they should be at least several days old—fresh eggs do not peel easily even if you know the secrets) in a pot not much bigger than the number of eggs you intend to boil. Cover with cold water. Turn the heat on high. Bring to a boil. Boil for a minute or two. Turn off the stove and let the eggs sit in the water until it is cool. I'd say the recipe is pretty much perfect.

—Maria VanC.

Bring a pan of water to a boil. Rinse eggs in warm water, then place in pan. Boil for 10 minutes. Then plunge eggs into cold water to stop the cooking. Works every time.

—Gail J.

Put the eggs in a pan of cold water. Heat until just beginning to boil (past simmer), then turn off the heat and cover the pan. Let sit for 10 minutes, then cool eggs by running cold water in the pan, in the sink, for 10 minutes. Roll each egg around the sides of the sink to break up the shell. Then begin peeling from the hollow end of the egg. I find that this method avoids that dark coloring of the yoke that otherwise appears.

Alternately, go to the Crystal Corner Bar, buy some pickled eggs, take them home, and soak them in water overnight to get rid of the vinegar.

—Jerry M.

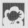

Get a pan. Put some eggs in it. Put in enough water to cover eggs plus an inch. Bring to a boil—and here's where it gets tricky. I may go off and do something else at this point, and remember about the eggs when the water's all boiled away and I smell them burning.

—Amy McG.

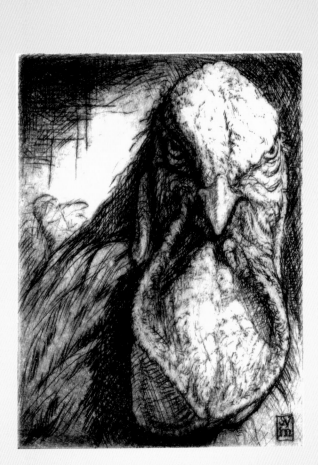

Maximus

THE NAME GAME

The Name Game

You can't be too careful when it comes to caring for baby chicks.

That's the alarming message of every book, Web site, or catalog devoted to chicken keeping. Fragile young fowl are prone to all manner of accidents and illness, and it quickly becomes obvious it's your responsibility to keep them healthy and safe.

For example, the Murray McMurray Hatchery catalog provides an entire page of detailed advice about how to help infant chicks, turkeys, guineas, pheasants, and partridge survive and thrive under the heading What Do We Do Now?

The proper light, bedding, feed, water, space, and temperature requirements are described, and so are things like draft shields and the size of a night light for baby birds (fifteen watts).

The bottom line? Do your homework and be prepared to protect your young birds from danger, discomfort, disease, and death. And do not doubt that all will stalk your chickens from the moment you take possession and then throughout their lives.

So, naturally, when we got our little flock home, I had the nursery set up as suggested in our secure garage with a cement floor, which would discourage rats with a yen for chick dinner. The baby birds seemed happy to move from shoebox to our brooder arrangement, which initially included a large,

sturdy cardboard box bedded with pine shavings in a wire dog crate, warmed by an overhead lamp, the temperature monitored with a thermometer.

Within the first several hours I had run from the house to the garage at least two dozen times to do chick checkups. Finally, I abandoned any pretense of trying to accomplish anything beyond a rather extreme version of bird watching. I dragged a lawn chair into the garage, so I could keep a constant eye on the birds and read up on chicken lore.

It wasn't an unpleasant task. Akin to watching things like clouds . . . or waves . . . or fire in a fireplace . . . or tropical fish drifting around a tank, the experience of watching chickens, I learned, has a kind of hypnotic, mesmerizing effect. Time drifted by in an extraordinarily pleasant way as I focused on the tiny fluff balls, pecking at their food, trotting back and forth, making soft, contented cheeping noises. Every so often, they'd drop in their tracks to take a quick nap.

By the end of the afternoon, I had also learned that my new little critters, full of peep and poop as they explored their new home, were already demonstrating rather unique personalities. And I knew it was important for me to get to know them well, because I'd struck a deal with Howard; by winter, I'd ultimately keep only four so this would be like "Survivor: The Chicken Ranch." It was up to me to determine

who'd get kicked off the island.

Of course, we wanted hens for eggs, so some of it would be simply the luck of gender, which we could only guess at this early stage of the game.

Furthermore, to know the chicks would be to name them. These were not anonymous birds invariably bound for coop or pot, but individuals whom we would choose as most worthy for various roles in our little chicken world and best suited to our farm's chicken needs. I was still a little vague about what would happen to those who didn't make the cut, but now the decision making had more drama and urgency.

In assigning my chicks their names, I aimed at something that would be both descriptive and gender neutral or flexible (not that the birds would care).

The bantam chicks, of course, were easiest to identify. They were tiny and already colorful. And their behavior was most different, too: active, sprightly, endlessly hopping off and on a smaller box in the brooder as they stretched and flexed their tiny wings. Because banties are often known for their flying abilities, we named the black chick Wittman, after a renowned Wisconsin flying ace, and the stripe-y one Beryl Markham, after the famous pioneering pilot of the 1930s.

A couple of the Buff Orpington chicks already seemed especially bonded with each other. One was large and confident, the other timid and anxious as it followed its pal, expressing baby bird concern whenever it felt it had gotten too many steps behind. This pair became Buffy (the Vampire Slayer) Orpington and Zelda (aka Flighty Fitzgerald) Orpington.

I imagined them as devoted, odd-couple roommates at prep school.

Three of the remaining Buff Orpington chicks were always hungry, placidly and constantly eating from the feeder, a trio of plump, even-tempered identical sisters, I hoped. Their names would have to wait until they developed some unique characteristics or I could put some kind of identifying bands on their legs.

And then there was an unmistakably bold chick—head and shoulders above the rest of the flock. Big, outgoing, and curious, this little bird was immediately easy to pick out of the crowd, by both appearance and attitude. Even as an infant, it raced over to check out anything new or interesting. By the end of that first day, it had developed the endearing habit of hopping on and off my hand, cocking its head in a most engaging way when I made *chick-chick-chick* sounds and generally acting as social director of the Buff Orpington booster club.

I found myself calling him Buddy—Buddy Orpington—even though I knew it would be months before there was any real way to know whether this was indeed a cockerel—young rooster. But I was already smitten with him, and his charm and good looks had me rethinking my initial prejudices against keeping a rooster.

Named and known, by nightfall of the first day my chicks had come home to roost.

❖

The First Chicken

Chickens were first domesticated more than 8,000 ago in what is now Thailand and Vietnam. Charles Darwin believed the domestic chicken (*Gallus domesticus*) descended exclusively from the red jungle fowl (*Gallus gallus*), but recent genetic research shows the gray jungle fowl (*Gallus sonneratii*) also contributed some genes. The red jungle fowl is still found in Southeast Asia, a rare case of a wild species that coexists with its domesticated descendants.

A member of the pheasant family, the red jungle fowl could be easily mistaken for one of the colorful domestic breeds. It has strikingly colorful plumes that vary from golden yellow to dark mahogany and a majestic red comb. It is visually distinguished from similar domestic birds primarily by its eclipse plumage. Eclipse is a dark and less colorful plumage that replaces the bright plumage of the breeding season, making the bird less visible to predators. Jungle fowl are more active and aggressive toward predators than domestic chickens.

While most animals were domesticated for meat, the red jungle fowl may have been valued for its fighting abilities. Some of the earliest pictures and references to chickens from India, Greece, Rome, and Egypt show fighting cocks and refer to their courage.

Archaeological evidence for chickens dates from about 7,400 years ago in China. They appeared in the Indus Valley about 4,000 years ago.

Chickens traveled with the trade caravans from India to Persia, modern day Iran, and from there to the rest of the Middle East. They reached Greece about 2,800 years ago, and soon after arrived in Rome, where the Romans considered them sacred to Mars, the god of war.

We know that chickens were brought to the Americas by the Spanish in about 1500, but they may have been introduced hundreds of years earlier by Polynesians sailing east across the Pacific Ocean.

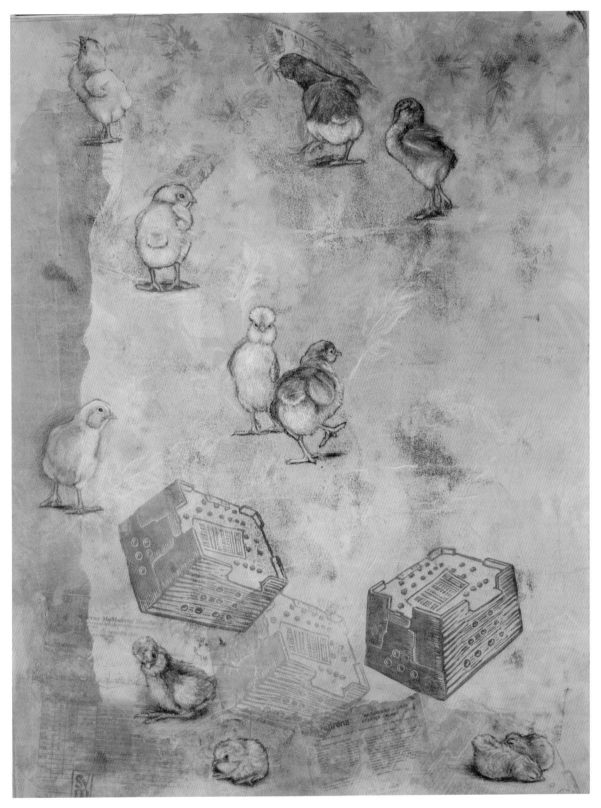

Spring Chicks

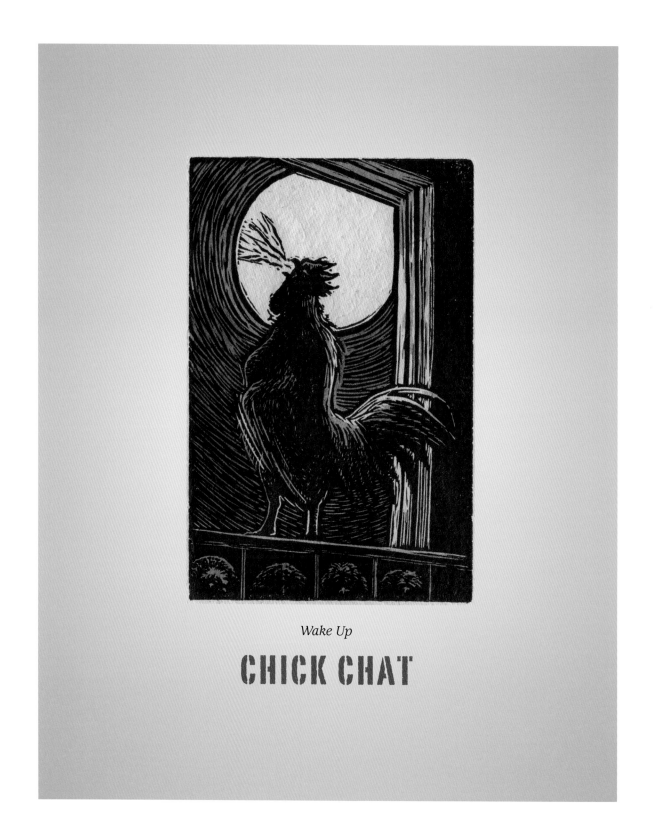

Wake Up

CHICK CHAT

Cock-a-doodle-huh?

We often ask small children what the chicken says, and they usually have a ready answer: Cluck, cluck, cluck or cock-a-doodle-do.

But there's far more to chicken chat than child's play.

Studies have shown that chickens make over thirty different sounds, and all of these vocalizations are associated with specific poultry communication efforts.

For new chicken owners, it may come as a surprise that their birds have so much to say in so many different ways about such a broad variety of topics.

When chickens chat about food, the sound is a comforting white noise that fades into the background, like the wind in the leaves. As they poke and peck about for various tidbits on the ground, there's a running, murmuring commentary that sounds a bit like ambitious, fully absorbed shoppers, urging themselves on from okay to better to best value.

"Gooooood....goooooood.......ggg-goooooooodddd......ggoooooooooddd..........ggg greeeeatt.....GRRRRREATTTT!!" they say, scouring the ground for seeds, or weeds, occasionally scoring the fabulous bug, kernel of corn, or bit of leftover pasta.

A hawk's shadow or unfamiliar dog may be announced with a loud screech of "*BUK BUK BUK BUK BA GA KUK KUK KUK, bagaw KUK KUK KUK, BAGAW KUK KUK.*" You say the sky is falling? If so, that would be the proper way to share that bit of unfortunate news, from a chicken's point of view, anyway.

If you are keeping chickens, you will want to learn the difference between an alarm call and the burst of excitement that attends the appearance of a new egg in the nest box. That might sound like "*buk buk buk buk BAUK BAUK BAUK KUK buk buk buk.*"

I assure you the chickens can tell the difference, even if it takes awhile for humans to make the subtle distinctions in phrasing, diction, and inflection.

If a rooster is asking his harem out for lunch, dinner, or breakfast in bed—and, by the way, there's no such thing as a free lunch among chickens—the words he uses to entice them is a seductive "*tuk tuk tuk tuk tuk tuk.*" It's usually uttered as he dances around, most likely with something in his mouth that he's happy to drop if they seem interested.

Then, of course, there's the difference in each rooster's crow. Our little bantam has always had a somewhat tentative call, and I've wondered if he prefaces it with a phrase like "Pardon, me, ma'am, no offense, but I'm about to announce the dawn . . . *ER ER ER A-ROO? Arooo?*"

Compare that to our big Buff Orpington rooster's master-of-the-universe shout:

"KA KA KA KA KA KA-ROOOOOO!!! KA-ROOOOOOOO!!! KA-ROOOOOO!" No doubt about the sun coming up after an announcement like that.

Besides the sheer range of vocalizing, I'm also intrigued by the fact that the Buff Orpingtons and the bantams seem to speak with a different accent, if not an entirely different language.

Despite their heritage as a British breed developed in the mid-nineteenth century, it seems to me that there's something vaguely Scandinavian about the way the Buff Orpingtons talk softly among themselves. *"Bluuuuk, bluuuuuuk, bluuuuuuuuk, bluuuu-uuggggg,"* they often seem to say as they are foraging peacefully, their accent a kind of predictable match to their sturdy, blonde Nordic looks.

The banties, quick and elegant, never speak like that. Instead, their foraging conversation is a charming, low, slightly more exotic sound: *"Briiiiiixxxxxx, briiiiixxxxxx, braaaaaaaack. Briiikkkkk, briikkk, brikkkk."* It's a wonder the Buffs and the banties can communicate at all.

But whatever their breeds, or communication challenges, chickens are rarely silent, chatting nearly nonstop, kind of like my grandmother's card party on steroids.

In fact, Meredith Willson's *Music Man* has a scene that parodies the ladies of fictional River City, Iowa, as a clutch of hens, clucking and feeding on "scratch": "Pick a little, talk a little, pick a little, talk a little, pick, pick, pick, talk a lot, pick a little more."

While Willson may not have been very kind to these small town biddies, he got it exactly right about the chickens.

❖

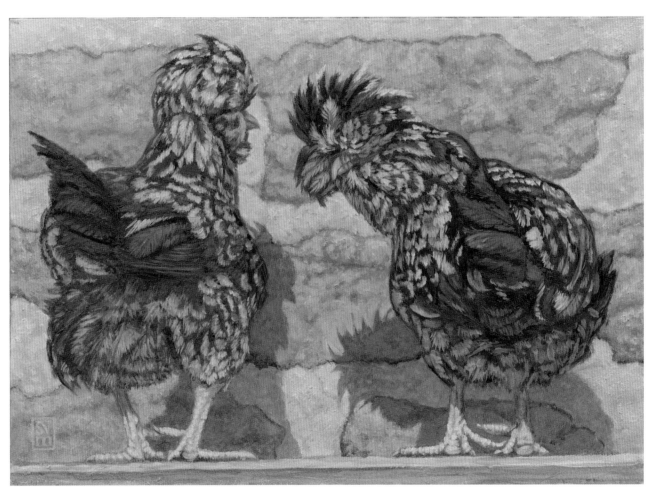

Private Conversation

Buddy to Bully

May turns to June, June to July. With a small flock of chicks you are watching closely, the passage of time feels accelerated because they grow so fast.

In just a few weeks our Buff Orpingtons changed from adorable golden balls of downy fluff to gawky, awkward adolescents. Their legs seemed to grow knobby almost overnight, and their feathers turned into a messy-looking pastiche of sizes and shapes that gave them a perpetual bad-hair-day look.

Meanwhile, my best chicken friend remained handsome Buddy. Unlike the other Orpingtons, he never went through an ugly phase as an adolescent.

He was always eager to be caught, racing over and nearly leaping into my arms if he thought I'd take him for a stroll. He seemed to love to chat and would look quizzically back at me when I spoke to him. He had the good sense not to try to fly much, as if he had a built-in aversion to looking ridiculous. I couldn't help smiling every time I looked at this oversize, good-looking chicken who I believed loved me best.

His comb grew quickly to a rich, scarlet color. His lustrous, golden feathers were always beautiful; he had the look of someone who spent a fortune at the salon. Even his weird chicken legs looked muscular and sort of tan rather than scaly and scary and bluish yellow.

When the crowing began in July, signaling that we did, indeed, have a rooster, I knew immediately by its confident tone that it could be no one other than Buddy Orpington. It was, right from the beginning, a big, bell-like cry: "I am. I am. I am," he seemed to shout, morning and night. His bold "*KA KA KA KA-ROOOOO*" was never timid or tentative, and he didn't seem to need any practice for that proud trumpet call.

But shortly after we began to hear Buddy's self-congratulatory shout-outs, we also became aware of another little cry of "*ER? ER? Er, er, er….arooooo?*" This was no alpha rooster for sure, based on his vocalization, but who was he, and what was he trying to say? And how would we deal with not one but two would-be leaders of the flock?

The voice was so soft, so almost apologetic that it was hard to pin down. But I had my suspicions as I began seeing Beryl sometimes roosting on the same roost as Buddy, and they often seemed to feed together, first thing in the morning. I began thinking of them as the boys, and the rest of the flock as the girls. I changed Beryl's name to Darrell.

Late one afternoon, the entire group of eight was out foraging in the brushy undergrowth beyond their coop. All of a sudden, there was a flurry of furious noise, screeching and squawking so loud that we

dashed up the hill to make sure some preda-tor hadn't decided to grab a chicken dinner during daylight.

By the time we arrived on the scene, whatever had gone wrong seemed over, and all chickens were present and accounted for. But that evening, when it was roosting time, Darrell was a no-show. I found him huddled under some branches, far from the flock, apparently prepared to sleep separately in the open. He happily took some treats from me and was willing to follow me back down the hill when I called. But he was very slow and limping badly, although I couldn't find any vis-ible injury.

There was no fuss when he went in to roost among the other chickens, and Buddy paid no attention to him whatsoever. But we didn't hear that gentle little crowing sound again for months.

Soon after, Buddy, who still raced to greet me with all kinds of chat and a great enthusiasm for any treats I might have, began to show a new interest in his fellow flock members.

I had read about rooster courtship rituals. Apparently, Buddy had not. Rather than waste his time luring his would-be girl-friends with treats or any displays of danc-ing or wing dragging, he seemed to favor a more direct approach. It involved standing

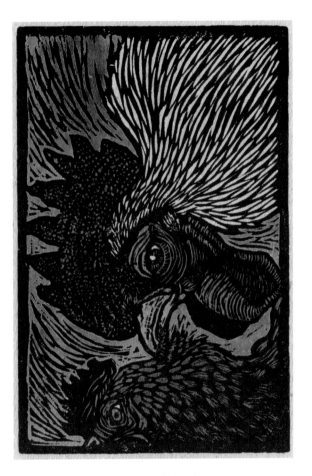

Unnecessary Roughness

quietly one moment and then jumping with all his force and ribald enthusiasm on an unsuspecting pullet.

She would shriek and struggle; he would hold onto anything he could get his beak or talons into. It wasn't long before all the Buff Orpingtons, the targets for Buddy's rough sex attention, had become flighty and neu-rotic. They were losing feathers. Following particularly rambunctious activity, they might limp or drag a wing. It was not a pretty sight.

It was a brutally hot July day when I finally had to make my decision about who would go and who would stay. Buddy made it fairly easy, actually.

I came home from work about 4 p.m., and the temperature at the back door registered ninety-six degrees in the shade. I was worried about the chickens in the heat and hoped they'd be perched somewhere under the breezy shelter of their fenced run. But no. It was only Buddy strutting about, airing his wings from time to time and sipping water in the shade. The girls, and Darrell, were nowhere to be seen.

I found the rest of the flock, minus Buddy, huddled in the blazing hot coop, panting, several of them with their eyes closed. They were apparently too intimidated to come out, and were obviously prepared to make themselves into roasted chickens rather than brave a confrontation with Buddy the bully.

With two roosters, and too many chickens to house through the winter, I had known from the beginning that some birds wouldn't make the final cut. Now it was clear who had to be sent away. For the health and safety of the rest of the flock, my beautiful, friendly, show-off Buddy, the chicken with a dazzling vertical takeoff when he wanted to pluck grapes out of my fingers, would be the first to go.

Rehoming a rooster, especially a pet rooster, is not an easy task. They are forbidden in most cities, and no one wants a rooster that's too rough with the hens, no matter what other charms he might have. I wasn't even sure Buddy would be friendly with anyone besides me, as he seemed fairly focused in his affection.

Ultimately, and with a heavy heart, I loaded him up in a large cat carrier and drove him over to my friend Anna's house. She had agreed to keep him until the fall butchering date for her group of Delaware roosters, and I believed Buddy's destiny as dinner for Anna and her family was an honorable one.

I carried my favorite chicken to his new home, a small coop set up for one big rooster. Buddy looked about, brave and alert. As I set him free in his new quarters, he was absolutely true to form, and began crowing that brash cry of his: "I am! I am! I. Am. Here!!!" he seemed to shout. Crowing from the other roosters ensued and Buddy strutted around his new digs, apparently scouting this new environment for any likely looking rape or pillage victims. If good looks alone had been enough, Buddy would have been a success among the ladies, but apparently among chickens, manners do matter when it comes to getting compliance.

As I petted Buddy goodbye, and then drove out the driveway, I'm pretty sure he didn't notice at all. But I hoped he wouldn't be too unhappy in his new, enforced life of celibacy and I wondered if somewhere in his chicken brain he would miss me. Anna said she would feed him grapes, and speak to him kindly.

Murder Most Fowl

It's inevitably dreadful tidings when an e-mail or any other correspondence from a friend has the word "murder" in the greeting or subject line.

Here's what Anna had to say, regarding some very dark news:

Today my roosters murdered Buddy. I feel terrible. Strong winds must have blown the door to his tractor open and it looks like he was jumped before he even had a chance to run. Even though he was intended for our freezer, I'm very sad about what happened to him. Vicious chickens.

Sorry to share the sad news.

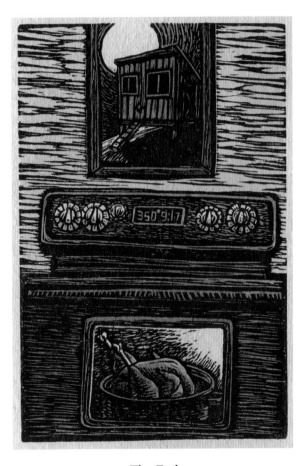

The End

Scrambled Eggs for Easter

Ben Logan

There was a special Easter ritual connected with egg-gathering. In some strange way egg-hiding got turned completely around for us. We boys did the egg-hiding.

Since I was official egg-gatherer, we had control of the supply. Weeks before Easter, I began slowly tapering off the number I took to the house each night, reserving the others for hiding. There was a sure signal when I went too far. Mother, who probably knew to the day when hiding began, would look into my egg bucket and say, "I just can't understand why the hens aren't laying better. You know I don't even have enough eggs for a cake."

When that happened, we'd ease off, sometimes slipping extra feed to the hens, hoping for increased production.

There were lots of good hiding places for eggs on the farm. The hens themselves had taught me about some of them. There were the corn-planter seed boxes, the empty water barrel of the tobacco planter, dark corners of the haymows, the oat bins. We learned with the years never to put them all in one place.

Slowly we built our hoard. The night before Easter we gathered them from their scattered hiding places and early Easter morning put the buckets of eggs on the front porch to be discovered. Father and Mother were always appropriately surprised and we had a happy Easter.

After Easter, Mother could bake freely again and poor old Mr. Finley, who candled eggs in the store at Seneca, had to work overtime. Candling was the way he checked to see if an egg was all right. He used an empty oatmeal box with a hole in the top and a candle inside. By holding an egg over the hole, letting the candlelight shine through, he could see if the yolk was whole and good. I can see that old man yet, bent over the oatmeal box in his dark corner, a green eyeshade pulled down over his forehead. We were paid only for the eggs that passed. He always seemed surprised that he never found a bad one. What he didn't know, of course, was that I had my own way of testing eggs.

Once, in the early spring, a neighbor woman came to call when Mother was making

a cake. "Get me four of the questionable eggs," Mother told me. I saw the neighbor woman's eyebrows go up.

I brought the eggs and Mother began breaking them, one by one, into a cup. "Those are the ones that haven't been set on more'n a few days," I explained.

The woman's eyebrows went up again. Lyle saw it that time. He was sitting in the kitchen mending harness, using the kitchen range to keep the sewing wax warm. "An egg is questionable only until it's broken," Lyle said. "People may fool you, but an egg can't."

Mother was busily beating the eggs and missed all this. The woman got up and said she'd better be going.

"Oh, I was hoping you'd stay for some cake," Mother said.

"No, thank you. I really couldn't," the woman said, backing out the kitchen door.

Mother watched her hurrying out of the yard. "Why, I wonder what's the matter with her?"

"Probably just didn't feel good," Lyle said. "Might have been something she ate." He winked at me.

Mother looked at him suspiciously and went back to her baking.

One of the things that makes egg-hiding interesting is the fragile nature of an egg. Eggs are a natural for a clandestine operation. When you lose, you lose with a dramatic smash.

Like the time we buried a nail keg full of eggs in the big bin of oats on the second floor of the granary. A few days later, Father sent Lyle up there to shovel oats. We didn't say anything, figuring they were buried deep enough to escape. Lyle was working away with the big scoop shovel when he hit the nail keg. He stopped whistling and began digging it out.

"Hell and tooter," he growled. "What's a nail keg doing in here?" He picked it up and gave it a heave. It landed at the top of the granary stairs and bounced down, spilling out scrambled eggs as it went.

Father, who had been working down below, looked up just in time to catch an egg on top of his head. He ran up the stairs, looking at the ceiling as though he expected to see a hundred hens up there that had all laid an egg at once. "Where the devil did those eggs come from?"

"Oats bin," Lyle said.

"For heaven's sake, why'd you throw them downstairs?"

"Now just a minute. If you was shoveling away and ran into a buried nail keg, would you right away suspect it had eggs in it?"

Father thought about that. "Well, no, but . . . "

"Figured it was empty as last year's bird's nest or just had oats in it," Lyle said. He scratched his head. "Well, that just might not be the truth. Fact is, I flung it out of there without doing any thinking."

"That makes sense to me," my short-tempered father said. He grinned. "Boys have to have their Easter egg fun, I guess." He was laughing as he started back downstairs. Then he slipped on the broken eggs. Down he went, bumping from step to step. He wound up with one foot stuck under the

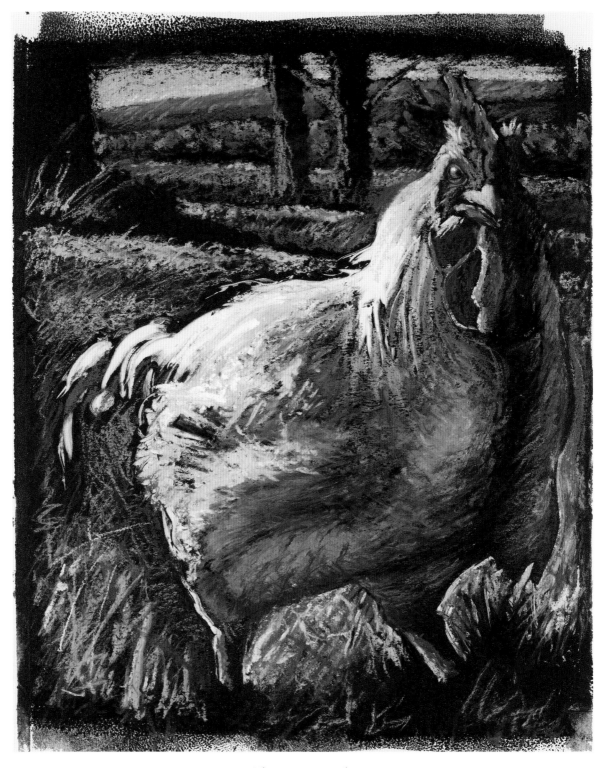

The Last Hurrah

last step where the bumblebees' nest was.

It was a little early in the season, but the bees were out to give it a try. Father ran out of there, flailing away. When he got rid of the bees, he stuck his head back in the granary door.

"Clean up that damned mess!" he roared at Lyle. "Keep those damned eggs out of the oats!" he shouted at us.

Everyone said, "Yes, sir!" at once.

We were a little short of eggs that Easter.

Right after that, Lyle began to be different about eggs. He was a short, wiry man with sparkling eyes and a sly smile. When he came to work on the farm, he was thin as a rail. It turned out he'd gone through a diet change. He'd been working in the Gays Mills creamery and he liked to drink fresh cream out of the farmers' cans. One day he dipped in and came up with a dead mouse. He cranked the telephone and started bawling out the farmer's wife.

"Oh," she said, "didn't I get them all out?"

He stopped drinking cream then. Stopped eating butter, too. That's why he was so thin. He liked eggs, though, but after the nail keg episode he didn't eat so many.

Eventually our egg-hiding reached a point where Father and Mother knew there would be eggs on the porch Easter morning. The only surprise was in the quantity, so we were trapped into topping ourselves each year.

One year we decided to make our greatest showing yet and quit. Easter was late and we coddled the hens into laying better than usual. But that wasn't all. We were going to fill two big washtubs three-quarters full of oats, then pile eggs on top. When Father and Mother saw those two heaping tubs of eggs on Easter morning, we figured they'd really be surprised.

It was a touchy business keeping all the eggs out of sight and the plan a secret. One night the weather turned cold. We gathered all the eggs into one place, then took turns sneaking out of bed to kind of sit over them to keep them from freezing. At the breakfast table next morning we had only to look at each other and the giggling would start.

Father eyed us suspiciously. "When boys start acting like that," he said to Mother, "there ought to be some kind of disaster insurance a man could take out."

Three days before Easter we heard Father tell Lyle to haul some old corn fodder out of the hay shed. That was where we had put all the eggs. We scurried out to move them to the woodshed, hoping no one would see. The eggs were already piled high over the oats in the tubs.

We made it all right with the first tub. Then, sneaking up the side of the yard with the second one, we all but ran over that same neighbor woman who had left once without any cake.

"Eggs," she said, looking at the full washtub. "Eggs!"

"We're just taking them to the woodshed," Lee said with a bright smile. We hurried on and left her standing there saying, "Eggs, eggs . . ."

When she went into the house, Lee sent me after her to try to keep her from

mentioning what she'd seen.

Mother wasn't baking this time. Unfortunately, though, she brought up the subject. "I'm sorry I can't offer you any cake. We just don't seem to be getting enough eggs lately."

The woman opened her mouth. I caught her eye and shook my head.

In a moment, Mother went into the pantry to grind coffee. I went over to the woman and whispered, "About those eggs. We'd just as soon you didn't say anything. Our mother's kind of funny about eggs right now."

All I meant was that Mother was about fed up with the egg shortage. But maybe this woman didn't have any background in hiding Easter eggs. She shook her head at me and got kind of a wild look.

When Mother came back and began making fresh coffee, the woman watched every move. I had an awful feeling that I knew what was going to happen next, but I didn't know any way to stop it. Sure enough, Mother broke an egg and stirred it into the freshly ground coffee. She put the pot on the stove and got down two of her good cups to have them ready. The woman got up and hurried out, hardly saying good-by.

"Why, that's the second time she's acted that way," Mother said with a worried look. I almost told her, but I remembered Lee, waiting outside, and decided a few more days of Mother and the neighbor woman each thinking the other was crazy wouldn't matter.

Father was the first one to see the two heaping tubs of eggs on the porch Easter morning. He shook his head, looked again, and shouted, "Holy smoke! Look what's on the porch!"

It was the best surprise reaction we'd ever gotten.

Lyle was just coming downstairs, his shirttail still out, his shoes in his hand. He was kind of excitable early in the morning before he really woke up. When Father shouted, Lyle dropped his shoes and went running out, yelling, "What is it? What is it?"

By the time he saw what it was, it was too late. One tub was closer to the door. He may have seen only that one, because he tried to jump over it. He almost made it, but one foot hooked onto the rim and went splashing down into the eggs. He slipped and danced for a while and finally crashed, bottom down, in the other tub.

That's a rare and beautiful sound, dozens of eggs breaking all at one time. It sounded like the ice going out of the Kickapoo River, and it was better than all the movie pie-throwing scenes put together.

Lyle wiped the splashed eggs out of his eyes and tried to get up. One foot was still in the other tub. He fell down again. The time it took him to get untangled from those tubs and wipe himself off was the closest thing to absolute silence I ever heard in that house. None of the four of us stayed around to see when the silence ended.

On the theory that the youngest child never gets punished as much, my brothers decided I should go back, two hours later, to see what was happening. I found everything quiet, the mess all cleaned

up. Mother was baking a cake, so I knew some of the eggs had made it. She was singing. As I watched, she began to smile. The smile grew into a chuckle and pretty soon she was laughing so hard there were tears running down her face.

It seemed like a good time to reestablish contact. I went in and told her about the neighbor woman. She started laughing all over again. "I'd better go see her," she said. "I'll bake something for her and . . . "

I shook my head.

"All right. Something without eggs," she promised.

Next I tried to reestablish contact with Lyle. I told him no one was mad about him breaking all those eggs and that Mother was even laughing about it. What he told me

took about ten minutes.

Every now and then during the next few days Lyle would start through a door, then suddenly stop and kind of freeze there with one foot in the air. Mother served cereal for breakfast for several mornings. Then she got tired of that and one day plunked a plate of fried eggs down on the table.

The four of us eased back in our chairs, ready to run. Father began to chuckle. Mother put a hand up to hide her face and retreated to the kitchen. Father gave up chuckling and began to roar. Lyle's face finally thawed out. He started laughing and helped himself to a fried egg. He never would eat his eggs scrambled after that Easter.

❖

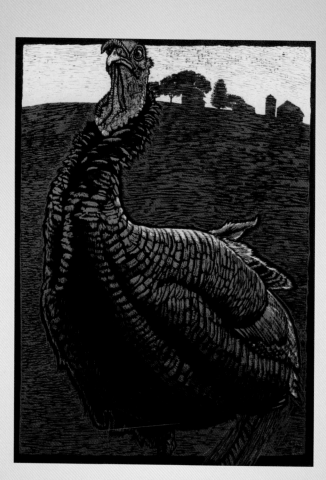

Turkey Promenade

WHAT A TURKEY

What a Turkey

My friend Virginia is not a flirt. First of all, she's over seventy years old and she has been married for many years. In addition, she's really too busy running a horse farm for any extracurricular romance. Finally, flirting isn't her style . . . never has been.

In short, there was nothing in Virginia's behavior that invited the unwelcome attention she got from a lovesick neighbor. Perhaps he was so smitten because he was raised by a widowed farmer and his bachelor son and Virginia happened to be the first two-legged female he had ever met. Maybe it was her voice. Or her clothes—the jeans and stocking cap and quilted nylon jacket.

Whatever. It was an odd obsession, no matter how you attempt to understand it.

But who knows what goes through the admittedly small brain of an adolescent wild turkey anyway? For reasons even he probably couldn't fathom, this turkey was devoted to Virginia, and there wasn't much anyone could do about it.

Every morning he'd eagerly fly across the road from the farm where he had been raised from an orphan poult. He was content to perch for hours on the roof of Virginia's farmhouse, eventually turning the ridgepole he'd chosen as his roost into an unappetizing shade of gray.

He'd wait patiently for her to walk out the door, and the moment she stepped outside to go to the stable to feed or water, clean stalls, or put the horses out in paddocks, the gangly young turkey hopped off the roof. Then, while Virginia went about her chores, the turkey was her constant companion, mincing and side-stepping, threatening anyone who came near with a fierce eye and a threatening hiss.

Obviously, he didn't relish competition. Sometimes he'd charge at the dogs, who responded with a mix of fear, annoyance, and confusion. Who could blame them? This was a pretty darn big bird, even for Gretchen the boxer.

Exasperated, often Virginia would try to discourage her most devoted fan but it had only a temporary effect. Tender toward every living critter, she didn't have the heart to really hurt her unwelcome suitor. Not that it was likely to have mattered. Loud noises, sharp words, a swat with a broom, the swish of a longe whip—the besotted turkey didn't react with fear to anything or anyone, with one odd exception.

He was terrified of a small barn cat named Gypsy. The cat was a fraction his size, but she was undaunted when it came to stalking him. He would run in terror of the mighty feline hunter whenever she appeared; she treated him with the same professional mix of casual but dangerous interest she applied to

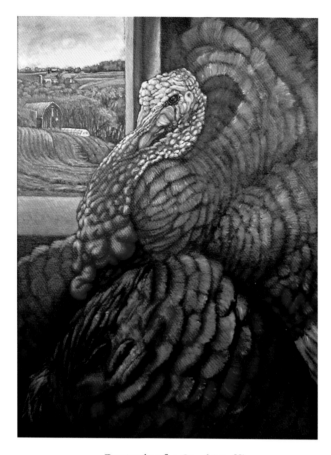

Portrait of a Stud Muffin

scary, purposeful stride, but if you pulled a purring, snoozing Gypsy out of your coat, he'd beat a hasty retreat. Sometimes I'd find myself backing toward the barn, cradling Gypsy like a feline tommy gun, keeping the turkey at bay.

My daughter, the college zoology major, went to the stable with me one day. Although I had earnestly reported my anxieties about the turkey, Bonnie didn't buy them.

Fresh from a trip to the jungles of Mexico where she had dodged scorpions and helped her professors band various and sundry wild birds, Bonnie told me that attitude was everything when it came to wildlife.

"He's not exactly wild," I tried to explain. "He's in love with Virginia, and he roosts on the house. You can do what you want but I'll be running as fast as I can to the barn if I can't find Gypsy."

I figured it was only fair for Bonnie to know, right off the bat, that mother love would go only so far in the face of a possible turkey attack.

No Gypsy. Luckily, no turkey in sight, either, but rather safe than sorry, I raced to the barn, panting with relief when I arrived unscathed.

Stately, leisurely, my smarty-boots daughter walked tall in my frantic wake. She was just a few strides short of the barn door when the turkey spied us and headed our way, looking disapproving at our presence.

Bonnie made it through the door just ahead of him. She smiled serenely.

"He's big, but you need to show confidence and authority," she explained. And then

anything that might qualify as prey. Perhaps she was dreaming of perpetual Thanksgiving as she'd give chase, lashing her tail or making that odd little chortle cats save for lethal bird watching.

Anyway, Gypsy's legion of admirers grew as she put the turkey in his place. Farm visitors and friends began carrying the cat around as preemptive protection from any turkey interaction. Who could blame us? He would approach with that angry eye and

we discovered we'd left our horse's bridle in the van.

She had already put the horse in the cross-ties and was beginning to brush him. So she asked, not unreasonably, if I wanted to go back to the car to retrieve the bridle.

I didn't hesitate. "No way. I'll brush. You can be a confident authority figure with the turkey. It'll be good for him."

My daughter is a tall, athletic sort of person, and she does have a confident way of walking that exudes authority, especially when she needs to teach her mother a lesson. At first the turkey was content to follow at a distance, glowering. But as Bonnie got out in the open the turkey started making little darting charges, hopping and hissing. My child picked up her pace, and he picked up his. She began trotting, waving her arms, and he did likewise, flapping his wings in a most alarming way. By the time she was within eight or ten yards of the van, she was sprinting, turkey in full chase mode, and she just managed to get in the van before the turkey hit the door.

I confess I will probably go to mother hell for this, but I was laughing. It got worse.

The turkey was circling the van, hopping up and down, looking in the windows. Bonnie was crouched down, trying to evade those evil eyes. After several minutes, the turkey moved to the back of the vehicle to wait her out. Bonnie, bridle in hand, burst through the driver's side door.

The girl is fleet of foot when she puts her mind to it, or she has an enraged turkey in hot pursuit. She was really moving by the time she got to the barn. I had the door wide open and waiting as she dashed through. With remarkable authority and confidence, I slammed it right in that turkey's face.

Not long afterward, the end of Virginia's turkey saga took place. Once again, the turkey was flying across the road, this time at an uncharacteristically low elevation. It was early and a driver, slightly blinded by the morning sun coming over the hill, had no time to brake as the big bird appeared directly in front of his car.

There was a gruesome crack, and the car and its shocked occupant were splattered with blood and feathers as the turkey came through the windshield. Stunned but able to keep his wits about him, the driver kept his car on the road, braking to a stop. He was shaken up, of course, but uninjured. The bird, en route to his daytime roost and the object of his undaunted affection, was dead on impact.

❖

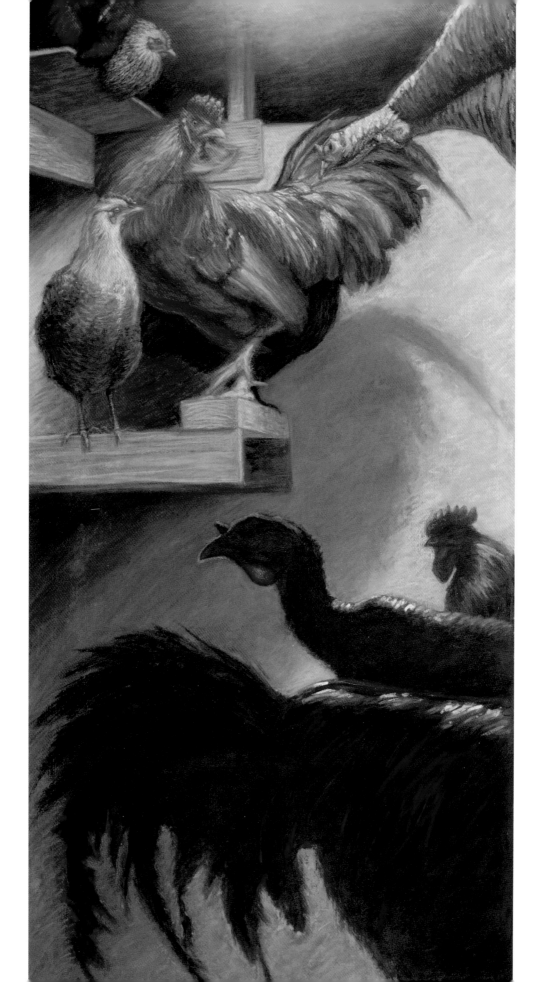

How to Hypnotize A Chicken

Michael Perry

In 1991, a time that seemed modern then, I pseudonymously self-published a slimmish book titled *How to Hypnotize a Chicken (Plus 30 Other Ways to Liven Up Your Life)*. The book was composed from the sweat of my brow and the breadth of my experience, which is to say I typed it up over the course of a short weekend.

Until recently, I thought all copies of the book had been dispersed. Then, while attempting to impose order on my pole barn (a giant steel shed designed to house farm implements but whose current principal occupants are Trash and Entropy), I unearthed a stray boxful. I peeled a copy from the top and began to read—an experience analogous to rounding a corner in a strange city and meeting my callower self clad in parachute pants and a mullet.

In short, this was writing that had yet to benefit from quality heartache and overdue health insurance premiums. Upon further recent review, I can tell you the contents are a flaming-faced embarrassment although I stand by the references to Pink Floyd, cloud watching, and—naturally—chicken hypnosis. In my memory, the chicken material consti-tuted an entire chapter. Turns out, it's just a single paragraph on page 33:

As long as we're talking farm animals, I might also mention that should you ever need to subdue a renegade chicken, you can hypnotize them by putting their head under one wing and rocking them in your arms. Don't remember who taught me that one, but it works. Just remember to wake them up before you leave. Poor things will starve if you just leave them snoozing.

If you can get past the egregious mis-deployment of *them/their*, this is a perfectly serviceable bit of instruction. Sadly (and perhaps because I was sitting at an electric type-writer in a pair of pants adorned with six decorative zippers when I composed it) the paragraph gives little consideration to aes-thetics. The head-tuck maneuver is unques-tionably effective (as children, we hypnotized our nastiest rooster just so before tossing him off the tip-top of the feed bin—the squawking flap-a-roo that erupted when he "came to" mid-freefall was the sort of thing that helped us forget we had no television) but leads to coarse behavior.

(left) Close Quarters

Time having mellowed (and de-mulleted) me, I now prefer the "finely-drawn-line" technique: Place the chicken on its breast with legs folded. Press the chicken gently groundward with one hand while using the other to grasp the chicken by the head and extend its neck (veeerry gingerly—we are not making Sunday dinner here) until its beak is flat to the earth and pointed dead ahead.

Placing the tip of your free index finger at the forward base of the chicken's comb, draw the fingertip forward from the brow out to the very tip of the beak, and then—without pause—inscribe a straight six-inch line in the dirt. Repeat ten or more times. When you are satisfied the bird has gone ga-ga, remove your hand and back away. If you have The Gift, the bird will blink but remain parked.

❖

Lulu

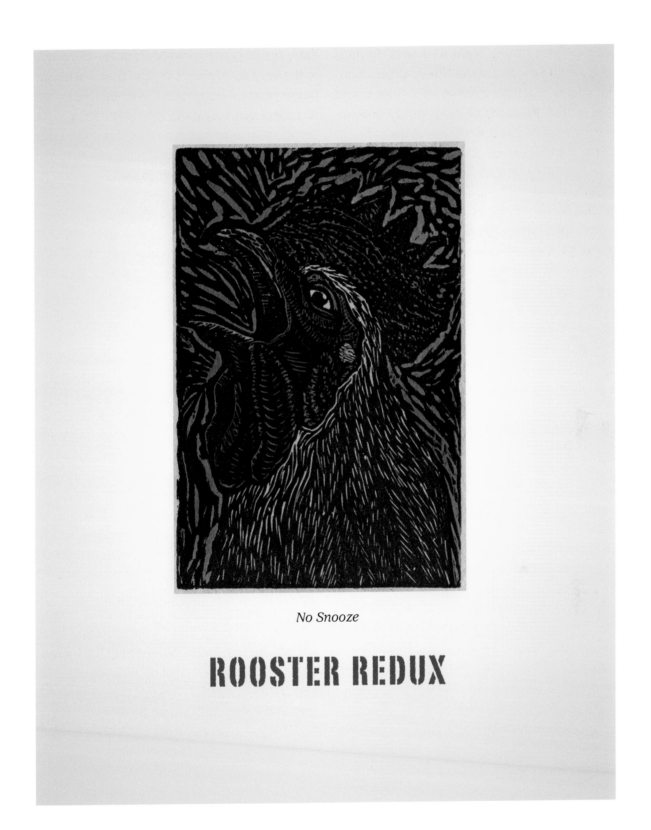

No Snooze

ROOSTER REDUX

Darrell Learns to Dance

It took some time for the flock to adjust to life without Buddy. For weeks, the young hens remained skittish, hesitant to come out of the coop in the morning. They'd stand at the open door at the top of their wooden ramp, shifting from one scaly, slender leg to the other, gently jostling each other, no one quite brave enough to risk the descent to the pen where, obviously, they still anticipated Buddy the bully might still be waiting.

Time went by and the coop and its surroundings remained eerily silent of any boastful crowing and mercifully free of the sounds of screeching, frantic pullets trying to escape Buddy's cruel, amorous grip.

Eventually, everyone relaxed. The flock settled into the serene summer pleasures of dust baths and bug watching, pecking through the grass and murmuring their hennish observations about gravel and acorns, weed seeds, and the occasional caterpillar.

Then, one morning, I was startled to hear a new sound, an odd sound, coming from the chicken yard. It was definitely chicken chat, but it wasn't quite like anything else I'd heard before. Soft and clear, and perhaps a bit tentative, it wasn't alarming in the least. With a distinct lilt at the end of each phrase, it sounded as if this was a bird asking a question, or politely begging pardon as it moved gently, but deliberately, through a crowd.

"Er, er, er, er, aroo? Arooo? Arrooo? Er, er, ah, ah, ahrooooo?"

The sound was coming from the beautiful bantam we had originally named Beryl, now called Darrell. With Buddy out of the script, this was our first evidence of a newly masculine Darrell. Obviously, he was auditioning for a new role as flock rooster, apparently tired of playing the invisible man. It was interesting, so I picked some blackberries for everyone; it seemed like something to celebrate. The fruit was a big hit, but it wasn't clear that the ladies thought much about Darrell's performance.

In the days to come, his crowing became more practiced, but it remained tentative, polite. After the disastrous experience with Buddy, I found his gentle, nonaggressive attitude charming. Even though the girls showed little interest, Darrell, unlike Buddy, seemed happy to use the go-slow approach.

Less than two-thirds the size of the big Buff Orpington pullets, Darrell is a handsome, diminutive bird. He has long, glossy bronze tail feathers that sweep up and back at a full, rakish angle. His saddle feathers are a gorgeous rusty shade of paprika, and he has a thick cowl of feathers around his shoulders that are the color of molten copper. I think he's beautiful, but it was hard to tell what the young hens were thinking. As his advocate, I couldn't help but suspect

they might be snickering at him, full of amused contempt.

He learned to make the soft *"tuk, tuk, tuk, tuk"* food call for especially tasty tidbits he had caught or found. A graceful and gracious gentleman, he stepped back and dropped anything in his mouth the moment one of the eager, hungry hens responded to his invitation for a free meal. They were happy to eat the bugs he snared but there was no after-dinner activity.

Sometimes Darrell would also do a quick little Groucho Marx shuffle toward one of the hens, obviously hoping to dazzle with his footwork. They'd just block him with a wing and a shrug that clearly said, "Nothing doing, Darrell. Get a life, but not with me." I could almost hear him sighing.

"So what's wrong with a nice guy?" I felt like yelling at my mean girl hens. "You sure didn't like Buddy the serial rapist, so maybe you should just count your blessings with a rooster who's little and friendly and gentle! And pretty! Don't forget, he's really pretty!"

But what I said seemed to fall on deaf chicken ears, sort of like trying to talk to your teenage daughter about drug-dealing snowboard dudes versus that nice fellow who sits next to her in band class.

I'm prepared to admit Darrell isn't perfect. Maybe the hens objected to his half-feathered legs, or didn't like the fact that one leg was partially a bluish slate color. Then there's his hairstyle. Even I have to admit it could be a problem. It's a bit like Alec Baldwin's in *Beetlejuice*, that longish, surprised-looking hair by Osterizer blender. And then, of course, combined with a full, Amish-style feather beard, it's a fairly weird overall look, even for chickens.

Months went by, and Darrell remained a sweet-tempered little guy, hanging out with the girls, nicely offering up food, guarding against hawks, and only occasionally asking, gently, if someone would please have sex with him. He didn't seem too discouraged by lack of success; unlike Buddy, he didn't just grab at what wasn't willingly given.

But then a miracle happened: Darrell learned to dance.

I saw it myself one evening, as Darrell began to sashay about. I was afraid he would suffer just one more embarrassing rejection.

But this time, he seemed to be paying no attention to the girls, and they were paying close attention to him. As a flamenco finale, he began dragging one of his wings in a graceful pattern around him, looking like a handsome small toreador, sweeping his cape in a mesmerizing circle. He finished his performance with a flourish and the hens, I swear, swooned.

Passion Dance

Darrell approached with lust in his heart and finally they didn't retreat or object. Then, as they say in the pounce-and-ravish novels, he had his way with them. Not with one, but two. There were no screeches, no bird screams, no feathers flying.

So, finally, art and patience won the day, triumphing over such other valuable chicken virtues as insect hunting and generous manners.

And now when I hear Darrell crowing his frequent question, greeting the dawn, the noonday sun, the dusk, and everything in between with his polite little *"Er? Er? Er? Ahroo? Ah? Ah? Ahroo?"* I think I understand what he's saying.

"Would you care to dance?"

Often, these days, the answer is yes.

Liberace

BIRDS OF A FEATHER

Birds of a Feather

Do dogs have personalities? That's an idiotic question, anyone who's ever loved a dog would say, akin to asking if a three-year-old child has a personality. Like people, every dog has his or her distinctive quirks and kinks, likes and dislikes. Some of those differences reflect individual temperament and experiences, and some reflect the breed or type of dog in question.

Our dogs are high energy, big personality critters. Among fellow animal lovers, we sometimes play a game of "who would play your dog in the movie version of his life?" We think Jeff Bridges would be well cast as our shaggy, tenacious, independent-minded mutt, Joe.

Meanwhile, someone like Natalie Portman would be a good choice to play Neesa, our leggy, sensitive Doberman. We have a friend with an overweight, stubby black Lab with a powerful personality: Danny DeVito is an absolute natural to play Luigi in the movies.

What about your dog? Or your neighbor's dog? Anyway, among animal lovers it's a notion good for a few laughs. But nobody thinks it's ridiculous to say a dog has a unique and discernible personality.

So who would play your chicken? It's not a question that would make any sense at all to a farmer with dozens or hundreds of hens. A factory farmer with 100,000 birds in sheds full of tiny wire cages? It's better not to think about personalities in that bleak environment.

But as chickens begin to populate backyards in cities and suburbs across the land, it gets more complicated. When chickens become individuals instead of commodities, it's impossible not to notice differences, and even to have favorites. And, as with dogs, some of the differences we see are the result of the critter's genetic background and breed, and some of it appears to be the difference of the individual.

For some fanciers, chickens have truly become pets, with all the pampering and personal interaction that implies. For most, they remain primarily a source of eggs and meat. Amusement at their antics or affectionate companionship are a bonus, but not the main point.

When we let our Buff Orpingtons out of their pen, we know it won't be long before they're headed for the house, especially if we're sitting on the porch enjoying a late afternoon drink or a Saturday lunch. When we are not outside in the garden or on the porch, the chickens may wander at will, but as soon as we come outside, we can count the minutes before they're scratching in the garden, picking green tomatoes off the vines, and even making themselves at home under our feet.

If we're not outside, our birds sometimes come up on the porch and peer in the back door, fixing us with their beady, velociraptor eyes. If that doesn't get our attention, they may go around to the other side of the house and climb the seven steps of the kitchen porch to check in through the windows to see what we're doing.

Throughout history, chickens have been bred primarily for their utility and their beauty. When they were bred for disposition, it was usually in the direction of aggression as fighters, not toward willingness to cuddle, or trainability.

Noble Hen

During the nineteenth century, when many of today's popular backyard breeds were developed, amateur breeders selected for egg production, hardiness, fast growth, and sometimes spectacular plumage. Getting chickens with a sociable nature was a helpful secondary trait, rarely a goal.

But thanks to all that selective breeding, and a renewed interest in the heritage breeds, we now have hundreds of chicken choices. If fresh eggs are at the top of your list, you can select a breed that was developed for egg production, not for meat. Many of the most popular backyard breeds today are dual purpose birds like Australorps, Rhode Island Reds, Barred Rocks, Buff Orpingtons, or Wyandottes. They also tend to be easy keepers, just in case you don't happen to be an experienced chicken trainer and veterinarian.

If exotic colors and fabulous plumage attract your interest, you might consider bantams. They lay small eggs, but look very distinctive with their sometimes jewel-like colors, and some types come with feathered feet and legs.

Polish chickens with their crazy mop of wild "hair" won't look like every other bird on the block. Silkies have a furry look. They are very sweet-tempered and often make good pets—the lap dogs of the chicken world.

If your goal is to amaze your friends and neighbors, the Ameraucanas might be your choice. They are sometimes called the "Easter eggers" because they lay lovely blue or green eggs, depending on the bird.

Chicken keepers who hope to develop a little pet-like rapport with their flock might want to stay away from the more flighty and nervous breeds, such as Sicilian Buttercups, Sebrights, or Leghorns.

These examples give only a hint at the rich variety of chickens. Whatever your intended relationship with the birds, chances are there's a breed for that. The examples that follow give only a hint at the rich variety.

Ameraucana: This bird is famous for laying beautiful eggs, but is also popular because it is a prolific layer. Ameraucanas may be black-blue, red, brown, buff, silver, wheat,

or white. Owner comment: "A few have been among the most curious and most easily handled birds we have owned."

Araucana: This South American breed may be black, white, blue, buff, silver, or a black-breasted red. They don't lay many eggs, and they aren't large, but they are reliably blue. Owner comment: "Decent layers, but no personality. That's no fun!"

Belgian D'Uccle (pronounced doo-clay): Comes in many colors and combinations of colors, including one variety with a golden neck. It's one of the most popular bantams. D'Uccles are quiet and friendly, but like most bantams, they love to fly. The hens are generally calm, but curious; some might even be considered adventurous. The cocks may be less aggressive than other varieties.

Brahma: A large bird that is gentle and easy to handle. May be light or dark colored. Owner comment: "Kind of like having a golden Lab transformed into a hen! Beautiful and hardy too."

Buckeye: These characteristically nut-brown birds are calm and friendly. They can be curious and are easily handled. Owner comment: "Some have been among the friendliest."

Buff Orpington: These plump, golden fowl are sometimes called the golden retrievers of the chicken world because they are quiet, docile, and may be friendly in a pet-like way. They are also handsome in a golden retriever sort of way.

Their black Australian cousins, the Australorps, have a similar reputation for being inquisitive and outgoing and are very hardy besides. In addition to the popular buff and black varieties, other Orpington varieties come in white or blue. Owner comment: "I have one hen, Cuddles, that demands to be petted or allowed to perch on your leg."

Cochin: Both the regular size and bantam Cochins (sometimes known as Shanghais) are known as easy handlers. Cochins may be white, black, buff, or partridge color. Owner comment: "Very easy for my daughter to hold, pet, and love."

Delaware: This classic white hen lays lots of large brown eggs. Owner comment: "They are the clowns of the yard and good layers summer and winter."

Leghorn: The common Leghorn ranges from shades of red or brown to white. If you ever drew pictures of chickens as a child, they probably were modeled on the ordinary white Leghorn. The Leghorn is such a prolific producer that it's the favorite commercial egg layer. However, Leghorns have an easily agitated personality that makes them less suitable for a backyard coop than a farm environment. They may avoid human contact. Owner comment: "The best layers but not that friendly."

Plymouth Rock: A docile bird that lays large pink or brown eggs, Rocks may be barred, white, buff, silver, partridge, and sometimes blue.

Barred Plymouth Rock: Known for their distinctive black-and-white, barred plumage. Most Rocks have a gentle personality. They become tame very quickly, and may be easily handled even by children. Rocks were once very common on small farms and homesteads and are still considered a good "starter" chicken for the backyard coop. Owner comment: "My Barred Rock is the friendliest, she gets picked up and petted by everyone. Lots of eggs too!"

Winter Light

Rhode Island Red: The official state bird of Rhode Island comes in one color only. They are prolific producers of large, brown eggs, which makes them one of the most popular breeds among chicken fanciers of all types. They're also known for being very hardy and resilient. Some owners find them friendly, but some find them too nervous and unreliable. The hens are active; the cocks are notoriously aggressive. Owner comment: "They always run up to greet me and sit at my feet until I pet them. They have been a joy to my whole family."

Sebright: This tiny bird is a beautifully laced true bantam that comes in silver and gold varieties. Like many bantams, the Sebright is described as jaunty and sprightly, which may appeal to those who are looking for big personalities, but may prove a handful to an inexperienced keeper. Also like many bantams, they are accomplished fliers, which can pose its own challenges.

Silkie: Probably the most popular bantam breed, the Silkie was developed in China before the arrival of Marco Polo in the thirteenth century. Silkies may be bearded or beardless and come in black, white, blue, buff, gray, and partridge. This crested, five-toed bird looks like it took a dust bath in the costume jewelry box, with feathered feet, turquoise earlobes, and hair-like plumage. They are generally hardy to heat and cold but not suited to wet weather because of their fancy feathers. They are said to be calm. Owner comment: "Docile, almost pet-quality temperament as well as adorable looks."

Welsummer: This energetic bird is a red partridge color and lays large, dark-brown or speckled brown eggs. It is considered to be more docile than flighty. Owner comment: "Lays consistently and is very chatty."

Wyandotte: The color patterns include silver laced, golden laced, white, buff, partridge, silver penciled, and Columbian. Silver Wyandottes are often praised for being calm and personable, as well as beautiful and reliable, if not prolific layers. Many stay aloof from human contact and some individual birds may be aggressive.

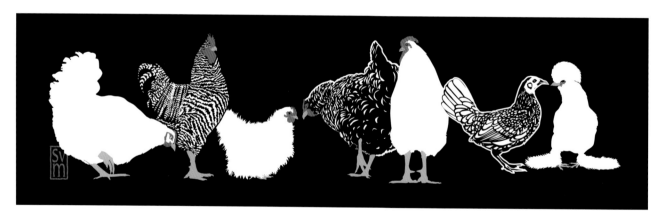

Chicken Lineup

There's a breed, it seems, for every taste and fancy. But can an individual chicken truly have a personality? It sure appears that way, based on our experiences. In a little flock there are big characters.

So what about that movie version of their life? My husband believes Scarlett Johansson is suited to play Buffy, our most glamorous and confident Buff Orpington hen; she's blonde and curvy, she's beautiful, and she knows what she wants. As for my cute and elegant black bantam, Wittman, who is small but edgy? I think Winona Ryder would be perfect.

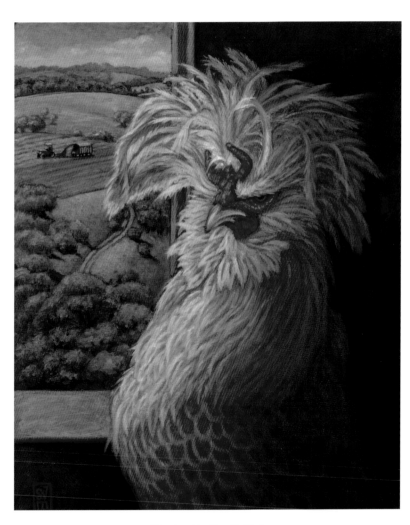

Portrait of a Polish

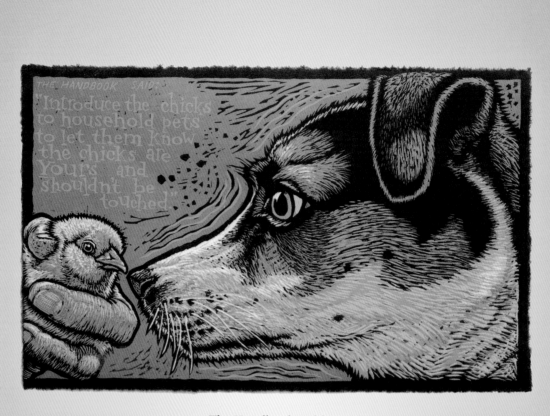

The Handbook Said . . .

THE ZEN OF HENS

We Cluck Therefore We Are

If beauty truly is in the eye of the beholder, what does a peacock see when he looks in a mirror?

If he is anything like my showboat roosters with their glossy tail feathers and richly colored hackle and saddle feathers, I wouldn't be altogether surprised to hear him break into a confident chorus of "I Feel Pretty," or something approximating that sentiment.

In reality, of course, peacocks are known for making an eerie screech that sounds like a human in distress, not for their ability to warble Broadway show tunes. But with some recent research suggesting that birds' brains are more complicated and complex than was once thought, perhaps it's not too much of a stretch to imagine that a peacock knows he's beautiful.

Certainly in the genetic derby, beauty in an extravagant form is the peacock's claim to fame. The longer his tail, the more spectacular his color, the more attractive he is to the peahens, or so we're told. But does he know he is ravishing to look at when he spreads that glorious tail to display that riot of glittering iridescence? Would he recognize himself as an individual?

There's no question that many birds are intelligent. Pigeons can remember hundreds of images for periods of several years. Crows are quick to learn any number of tricks, including learning to dodge cars by clever and judicious use of stop and go lights.

Alex, the famous African gray parrot trained by Irene Pepperberg, not only knew plenty of words and used them appropriately, he also learned abstract concepts like numbers and colors and even used different language when referring to himself or others, indicating a concept of "I" and "you."

But back to the peacock and the mirror: Are bird brains big enough to have a concept of self? Until quite recently, scientists agreed that the notion of self-awareness was exceedingly rare in creatures other than humans. Studies and observations proved that there were exceptions, including great apes, bottlenose dolphins, killer whales, and Asian elephants, but few would have extended that notion of self-awareness, or the ability to distinguish one's own body from others, to birds or other non-mammals.

In laboratory tests, behaviorists often use a mirror to see whether their experimental subjects can recognize themselves. And now, recent research is broadening the concept of who and what is self-aware. For example, magpies are able to recognize themselves in a mirror image, and pigeons recognize video images of themselves, even with a five-second delay.

These studies not only extend the self-awareness club to non-mammals, but also demonstrate that self-recognition can occur in species without a neocortex, the part of the brain crucial to self-recognition in mammals.

My own non-scientific test of self-awareness is the ability to understand how others see you. Dogs, of course, recognize other dogs as members of their same species, no matter what their size, breed, characteristics, or situation. A Great Dane recognizes a Yorkshire terrier as a dog, and vice versa. But that internal concept of species isn't the self-awareness I'm talking about.

More impressive is how our pet dogs learn the human concept of "dog" in different contexts. When they hear us use the word in conversation, our dogs often run to the window and bark, assuming that there must be a dog outside. But when we say "dogs" referring to them—for example, "I wonder if the dogs want to go in the truck?" or "Dogs, stop fighting on the rug!"—they typically respond as if they know the word "dog" applies to them. So they seem to understand this human-determined word category and recognize that it applies both to themselves and to dogs in general. It may not meet the rigor of the mirror test, but it's pretty close to self-awareness in my book.

As for chickens, poultry, even peafowl, I'm not sure they respond to much human language, except when someone sings out "*chick . . . chick . . . chick . . . chick*" with a handful of treats. They do have bird brains, after all.

But when it comes to self-confidence, my colorful bantam rooster and absolutely elegant tiny black hen have learned a secret of living well. Unique among the flock of big, plump Buff Orpington hens, they never seem to see themselves as outsiders. Darrell and Wittman may not recognize themselves in a mirror, but they apparently believe they are beautiful.

❖

(right) Upstaged by a Chicken

Guess Who's Coming to Dinner?

Until we had chickens, I hadn't really been tested or challenged on one of the fundamental rules of our animal-loving but decidedly non-vegetarian household: We don't eat pets.

The practical argument that we don't put friends on the menu made sense to our kids, and helped them understand why we would never have our Shetland pony, Raisin, for dinner, but we would eat the steers, Raging and Courageous. We made a point of not making pets out of the cattle, although we cared for them diligently.

"Their lives on our farm are good," we explained. "We give them hay and grain and fresh water. We make sure they have shelter and are comfortable and are never afraid, or hungry or thirsty. We feed them for a year, and then they feed us for a year."

Meanwhile, despite the name, Raisin wasn't edible because she, unlike the steers, was a pet, and a friend. Tied with yarn to the swing set, she seemed to enjoy being part of pretend circuses or acrobatic acts. She wore feathers for dress-up and sometimes clattered up a few steps onto the back porch for apples, carrots, or peppermint candies. As a kind of karmic calculus, it worked for us.

Over time, we have become more mindful of where our meat comes from and how the animals lived. We like to know the person who raised the animals and, yes, even the person who killed them. But we have little desire to stop eating meat, not just because we like the taste or enjoy cooking, but because we recognize meat eating as part of our natures— part of a larger nature that we partake in.

I have to say that I agree with the comment Michael Pollan made in a *Frontline* interview: "A cow out on grass is just an incredible thing to behold. We can't digest grass. So to take land that is not good enough for agriculture—that's growing grass and nothing else, that's been doing that for 10,000 years since the buffalo—and put a cow on it . . . there's something beautiful about that, and it's just the way it was meant to be."

We have eaten many animals whom we have known personally. Some are easier to eat than others.

For example, before I bought pork from a friend, I went to his farm to look at his group of young pastured pigs. They were handsome, eager young critters, crowding the fence and angrily jostling each other as they fought over choice leftovers from a nearby organic restaurant. I confess, I worried that the low electric wire circling their pen might not be sufficient to hold back their greedy vigor.

(left) Highland Afternoon

First Feathers

CLUCK

It was a revelation to recognize that while I might be eyeing them as a potential future meal, they were possibly looking at me, or my friend's three year-old-niece, with the same notion in mind.

When it came to getting our little group of chickens with the intention of having laying hens, the lines between pets and candidates for the table blurred a bit. Originally, we didn't even know which chicks were girls and which were boys. It did seem rather unfair and arbitrary, to say nothing of it being the ultimate sexism, that a gregarious chick shouldn't be encouraged to be friendly because it might grow up to be a rooster, ultimately bound for the grill or stew pot.

During the first few weeks, I spent hours carefully holding the little chicks to tame them, watching them with growing fascination as they revealed their distinctive personalities. One could fly up on any little obstacle in the brooder box, another always hung back at feeding time, still another always seemed to bustle about, appearing to order the rest of the tiny flock around. And all of them made a big enthusiastic rush toward my hands when I fed them, cheeping with excitement.

Oh, oh. Pretty pet-like.

During those first weeks with the adorable little balls of downy fluff, I have to confess I did not have much of an appetite for chicken, and I wondered if this new antipathy would become permanent.

I'd considered culinary decisions before getting chickens: As I cared for them and got to know them up close and personal,

would I still be willing to eat chicken in general, presumably chickens who did not have names? Or would I even be able to eat my own sociable birds?

Over the next couple of months, my fond interest in my own birds grew. They were definitely becoming individuals, and I'm pretty sure I'll never be able to eat them. But the rest of their fellows? I confess, my hunger for fowl has returned.

So why can I still eat chicken in general, just not chickens from my own flock?

I suppose it's partly that I recognize the chickens fall into a category that's somewhere between our cattle and our cats—not house pets (although if a chicken is sick, it's been known to be nursed back to health in the basement or bathroom) but not strictly farm animals, either.

But there's something else besides. My chickens' regard for me (and there's plenty of evidence they specifically know and trust me) is built on a more primitive base than the complex bond of deep affection and mutual respect I have with my horses, cats, and dogs, which I define as love. The chickens know I feed them, and they love to eat; it's almost that simple.

Like humans, and like pigs, chickens are enthusiastic omnivores. They consider everything—or at least almost everything—a potential meal. I wasn't too surprised when they gobbled up dog kibble and horse grain as well as the organic chicken meal we provide for them. It made sense that they went crazy for blackberries, bugs, and earthworms.

But it was a revelation when I saw

them attack a tiny garter snake en masse, and pin a mouse in a corner. Of course, they also adore cottage cheese and tuna fish, pasta and scrambled eggs.

They even snap at my toes when I'm wearing bright nail polish, and grab at the sparkle of jewelry, like little avian land sharks. It actually feels a bit like a scene out of *Jurassic Park* when I occasionally give them meat scraps. They descend in a squabble of peck and grab, especially when there are pork chop bones. I deliberately don't ever give them, ahem, chicken scraps because I don't want to encourage any notions of cannibalism. I'm aware they wouldn't be unhappy to eat their own.

And here's the thing: When I look into their hard, hungry, bright eyes, I know they'd eat me up in a flash if I were the right size. It wouldn't be personal. In the meantime, we're friends.

Waddling Toward Destiny

Howard Cosgrove

Kim Keyes for *Isthmus*

Susan and Darrell

S.V. and Liberace

Susan Troller got her first pet as a birthday gift when she was eight and she never looked back. Since that first Siamese cat, she has lived with a movable feast of furred and feathered friends—currently numbering 14—that has included cats, dogs, horses, goats, steers, heifers, guinea pigs, birds, rabbits, and now chickens.

Her interest in chickens took wing when she was introduced to Consuela, the miraculous survivor of a mass gassing of laying hens at a factory farm and the star of the 2006 documentary film *Mad City Chickens: The Return of the Urban Backyard Chicken!* She got her own flock of hand-raised chicks in the spring of 2010.

Susan lives with her chickens, dogs, cats, a whole family of horses who were all born on the sixth of June, and her husband on a small farm near New Glarus, Wisconsin, where they raised three animal-loving daughters who are now grown and have their own pets. In her other life she is an award-winning newspaper reporter for the *Capital Times* in Madison, where she has written about the thriving local food movement and currently covers K-12 education.

S.V. (Sue) Medaris has lived on a farm in the Driftless area of southern Wisconsin since 1998, and raises dogs, cats, chickens, peafowl, turkeys, and pigs from which she draws inspiration for life and art. Her current family includes husband, James, and muses (dogs: Dexter, Zuzu, Ivan; and cats: Hairy and Cisco), along with 25-40 chickens, and George and Gracie (peacock and hen). Various pigs, turkeys, and broilers are raised for meat and inhabit the farm from spring to fall.

After ten successful solo exhibitions in eight years, each of them focused on domestic animal husbandry (*A One Chick Show*, *The Lives of Farm Dogs*, *The Whole Hog, Corn-Fed*), the artist continues to investigate historical changes in livestock rearing, breed genetics, feed consumption, processing animals for meat, and their effect on our lives and the food we eat.

The artwork explores our relationship with the animals we raise for consumption as well as those we care for in companionship.

More information at svmedaris.com

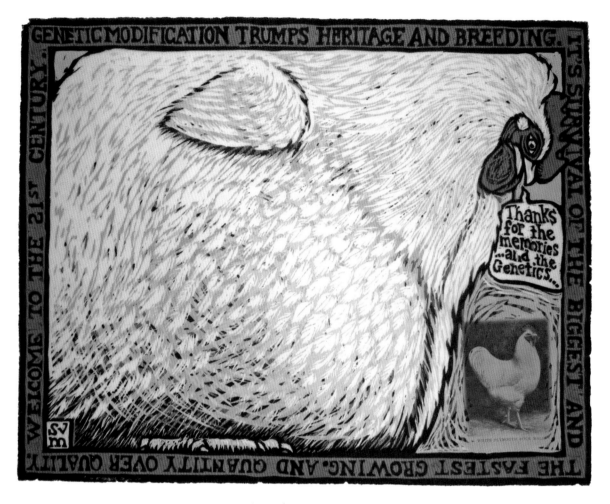

Genetic Opposition

CLUCK: FROM JUNGLE FOWL TO CITY CHICKS is Portagol ITC TT.
Subheads are Jaft ITC;
Text is from the Usherwood family;
GillSans appears on select pages.

CLUCK is printed on acid-free and recycled content paper.